Doodling *for* Writers

ADVANCE PRAISE FOR *DOODLING FOR WRITERS*

"Rebecca Fish Ewan's *Doodling for Writers* is a super-fun book, but it's also subversive, giving a view into the mechanics of creativity while posing as a craft book. Not only will this wonderful volume take a seat on the shelf next to Hillary Chute's *Why Comics?*, Scott McCloud's *Making Comics*, and Lynda Barry's *Syllabus*—it extends the conversation about how visual thinking can help us all. All writers benefit from a comics mindset, Fish Ewan proposes. Part an inspirational call to one's inner artist, part a compendium of engaging and inspiring prompts, part a quintessential work of show don't tell, *Doodling for Writers* is full of good cheer and wise words."

– Elizabeth Kadetsky, author of *The Memory Eaters*

"A delightful and wise guide to creative empowerment through the understated power of the doodle. Rebecca Fish Ewan is the perfect drawing buddy, and *Doodling for Writers* contains a wealth of practical advice to get you drawing and visual perspectives to enrich your writing. It's essential reading for any writer who draws or who aspires to, even if you doubt your artistic abilities. With this book as your companion, you'll be happily drawing before you know it."

– Vanessa Berry, author of *Mirror Sydney*

"I love this book! Insightful, instructive, charming, and encouraging, Rebecca Fish Ewan's prompts and provocations will open new doors into your writing practice – and a drawing practice, too. In *Doodling for Writers*, erasers are like editors, lines have – or are – their own vocabulary, writers can be deciduous, and pleasure is paramount. A mix of practical advice and inspiring prompts, this book is a must for any writer who wants to enrich their process. It's also a gentle but complete rebuttal of the all-too-common claim, "I can't draw." You can! And this book delightfully shows you how."

– Randon Billings Noble, author of *Be with Me Always*

"*Doodling for Writers* gently takes the reluctant drawer on a masterful journey into the vast world of doodling. Full of easy to follow prompts and direct ways to connect doodling to the writing process, this book will be a must-have on any writer's shelf. It's funny, rich, irreverent and profoundly relevant to today's creatives."

– Laraine Herring, author of *A Constellation of Ghosts: A Speculative Memoir with Ravens*

REVIEWS & PRAISE FOR
BY THE FORCES OF GRAVITY: A MEMOIR

"By combining poetry, illustration, and comics, Rebecca went completely outside the traditional storytelling format and created a wholly captivating book that takes the reader through the entire spectrum of emotion, from heartbreak to hilarity...Rebecca's real talent lies in her ability to capture exactly what it feels like to be young, confused, and fascinated by the world and relay that information in a way that feels honest, real, and raw, which is really all I want in a story, because that's what really matters."

– Julia Wertz, *New Yorker* cartoonist and author of *Tenements, Towers & Trash*

"Girlhood friendship is the strongest force in the universe in this stirring memoir of 1970s Berkeley."

– *Publishers Weekly*

"Rebecca Fish Ewan has invented a wildly unique new genre that will transport you to a wildly unique time and place where love and experimentation reigned, children were intentionally left unparented, and everyone, it seemed, spent their days chasing far-out trips. In this vividly magical and terrifying world, a once-in-a-lifetime friendship blooms between two girls. At turns utopian and tragic, *By the Forces of Gravity* will forever change the way you think about love, childhood, the meaning of family, and what it means to be fully alive."

— Ariel Gore, author of *We Were Witches*

"*By the Forces of Gravity* is a genre-bending masterpiece like nothing else written."

— *Literary Kitchen*

"Rebecca Fish Ewan's inventive prose and picture narrative recreates the tumultuous counter-culture movement in Berkeley, California, capturing the intricate, psychedelic zeitgeist of the 1970s. Together, the drawings and text weave an intimate story of a young girl finding her soulmate and mentor as they search for cosmic consciousness. This free-verse-comic takes us on an epic trip of alternative lifestyles, sex, drugs, rock-and-roll, loss and, ultimately, redemption."

— Chip Sullivan, author of *Cartooning the Landscape*

"*By the Forces of Gravity* is a groovy and occasionally heavy tale that will captivate former flower children and idealistic millennials alike."

— *Phoenix Magazine*

"Rebecca Fish Ewan's free verse is clear and immediately immerses the reader in the thoughts of young Becky Star Fish, and the accompanying drawings deepen the emotional resonance of the book, allowing us another way to access the thoughts and feelings of a narrator we can't help but feel affection for.... An unflinching work of tender beauty, *By the Forces of Gravity* is an intimate memoir to be savored, re-read, and shared with your own soul friends."

"Fish Ewan's memoir-in-free-verse is a compelling auto-ethnography of a wayward childhood, loss of innocence, & search for love."

"Full of the raw honesty and complicated tangles of a young girl navigating the lost and found of adolescence friendship and the journey toward selfhood in 1970s Berkeley—the drawings as necessary and revealing as the doodles in the margins of her lessons."

"Fish Ewan's imaginative orbit is undeniable. *By the Forces of Gravity* is a wrenching, delightful freefall—full of wry humor, love, and the sort of wisdom so compacted and understated it could have been forged only in the space-time magic of this author's own luminous vision."

Doodling
for
Writers

BY REBECCA FISH EWAN

ISBN: 978-0-9994299-3-8

Printed in the United States of America.

Books by Hippocampus
An imprint of Hippocampus Magazine and Books LLC
210 W. Grant Street
Suite 108
Lancaster, PA 17603

books.hippocampusmagazine.com
books@hippocampusmagazine.com

Cover and book design by Lindsay Enochs
Illustrations by Rebecca Fish Ewan
Typefaces: Adobe Caslon Pro, Laski Slab, and URW DIN SemiCond

Every writer with a desire to draw who has been afraid to begin

Every writer who says with sadness "I drew as a kid," but stopped

Every writer who yearns to draw, but needs a nudge to get started

I dedicate this book to you

Table of Contents

INTRODUCTION
Launch Nerves . **xi**

SECTION ONE: DRAWING PRACTICE AND TECHNIQUES

1.0 Introduction . **1**

1.1 Drawing Tools . **3**

1.2 Line Weight . **14**

1.3 Line Vocabulary . **20**

1.4 The Diagonal . **28**

1.5 Light and Shadow . **38**

1.6 Perspective . **50**

1.7 Graphic Composition **60**

SECTION TWO: DRAWING APPLICATION
IN THE WRITING PROCESS

2.0 Introduction **74**

2.1 Character Sketches **76**

2.2 Character Accessories **80**

2.3 Drawing to Learn **84**

2.4 Drawing When Blocked **90**

2.5 Mental Maps **98**

2.6 Place Maps **106**

2.7 Visual Shorthand **114**

SECTION THREE: HYBRID FORM

Hybrid Form: Words and Drawings **124**

SECTION FOUR: TAIL END

4.0 Introduction **134**

4.1 Resources and Inspiration **136**

4.2 Extra Credit Prompts **144**

Introduction

When you meet a surgeon, do you lead with a confession that you have no scalpel skills?

I don't.

But when writers find out that I draw, they often confess to me, "I can't draw" or declare, unprovoked, "I'm not an artist." There's a shadow of sadness in their voice.

I feel the hauntings of that kid in third grade who told these writers that their crayon renderings of elephants sucked or the teachers who took their pencils away because doodling distracts from learning real stuff, like, when, to, use, commas.

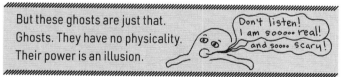

But these ghosts are just that. Ghosts. They have no physicality. Their power is an illusion.

Don't listen! I am sooooo real! and sooooo scary!

This book is meant to help you let drawing be a part of your writing life. It endeavors, through action and encouragement, to enable you to see that "I can't draw" and "I'm not an artist" no longer need to hold sway over you. This book, though small, will provide enough force to swat these annoying mental flies that have buzzed in your writer mind since childhood. The flies that land on a pencil and keep you from picking it up to doodle.

Many how-to drawing books offer three steps to drawing a particular object (apple, cat, jungle animal, seascape, house, whale…). These steps are almost always the same.

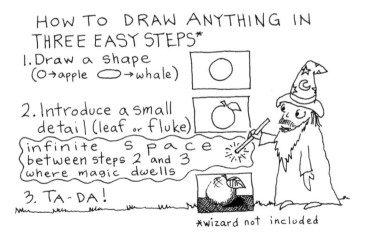

What is left out in these books is the magic that occurs between steps 2 and 3. Without this magic, most readers are left at the edge of step 2, feeling abandoned.

There's another way to learn to draw in three steps:

1. Believe there is another way to learn to draw
2. Hold a pencil (or a pen)
3. Draw

Here's a hard and fast truth:
If you can write, you can draw. Period.

You may never draw as well as that kid in third grade whose house-with-tree-and-smiling-sun sketch always seemed better than yours. This matters not one bit. Drawing can enrich your writing life, regardless of the visual appeal of the drawing, so helping you let go of the long-held I-can't-draw myth, to free up room in your heart to doodle with abandon, is why this book exists. Quality relates to a drawing's usefulness not its aesthetic value or even the expertise inherent in its craft. Sucking at drawing is irrelevant and BTW your imagination is a this-sucks-free zone! If your drawings help thoughts form and emerge from your mind, they are useful drawings.

One of my favorite vintage bookstore finds is *Sketching is Fun with Pencil and Pen* by Alois Fabry, released in 1958. The entire book expresses his belief in the joy of drawing. He cautions new doodlers:

> "Never allow yourself to be discouraged. Rest between times—then sketch again."

Learning to draw is a process, one you started as a child and have been honing ever since, anytime you've held a pencil or pen or looked at the world. Deciding to venture deeper into the vast doodleverse can feel frightening. As you explore, with this book and beyond it, when you feel discouragement looming, *rest between times—then sketch again.*

If you fear failure, think about drawing like driving a car (or whatever mode of transportation you use). There's no need to excel at it. You just need to get where you want to go. Even when you aren't sure where you're going.

We'll begin with brief information on the tools you'll need to get started. If you already have a pencil/pen and some paper, you can skip ahead to the sections on drawing techniques and visual composition. If you find that your writing tools don't work for you as drawing tools, or you want an excuse for a shopping spree in your favorite art supply store, you can always check out the tools portion later. It'll still be there.

Lots of people are using digital tablets, and you may want to learn to draw using a digital pen and tablet. This book is still

for you! The tools section covers analog drawing tools—but you can do all the prompts in the book with a digital pen—and all the drawing tips and practice still apply to digital drawing, but this is the only technical advice I have to offer: try turning it off and then on again.

After the tools and techniques section, the book is all about writing. Actually, the whole book is about writing. How drawing can feed the writing. You're a writer. Putting words on a page grounds you, fulfills you, taps into the passionate volcanoes in your soul. Drawing won't take that away.

But, you might argue, it'll steal my precious writing time! No. Drawing can have a few of the other more idle moments you spend doing less essential stuff, like tweeting #imnotdrawingorwritingrightnowbecauseimontwitter. *Doodling for Writers* is designed to provide ways to incorporate

drawing into your writing life, not replace it. You might even find that drawing gives you more time for writing, because your drawings accelerate how you visualize scenes, picture characters or navigate through a chapter. Your drawings can become road maps to where your writing needs to go.

Yay, road trip!

Here's another hard and fast truth:

It's possible to find your voice in both words and drawings. I have read on the internets and heard it said with mouths that this is not possible. That one must choose between one or the other. Hogwash! Why must one choose? Human history is stuffed full of people who have excelled at more than one thing (Nostradamus wrote a cookbook, Albert Einstein played the violin, Emily Dickinson made zines, David Bowie painted, Rita Hayworth danced, Susan Sontag directed films and taught philosophy). Besides, drawing and writing are very similar. They are both the act of making marks on paper to tell stories, convey ideas, record; for instance, the stories of how Mary Wollstonecraft wrote AND was an activist for women's rights, or how Mary Catherine Bateson writes AND is a cultural anthropologist. Same for her mom, Margaret Mead. You don't have to choose. You can write AND draw. Simple as that.

What follows are a series of small nibbles, hors d'oeuvres if you will, of essentials for making drawing a part of your writing life. The book includes prompts to get you drawing, along

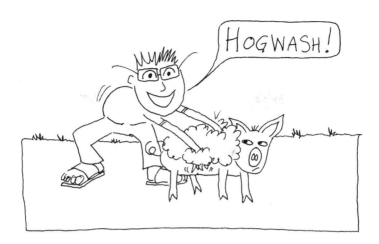

with drawing tips and encouragement. The Tail End section includes resources on drawing, so you can continue your exploration in the doodleverse, and a list of books by writer/drawers for further inspiration.

The Doodle Prompts

You'll find doodle prompts throughout that are linked to the topic at hand. While they are organized in a logical sequence, in that the prompts in section two might use vocabulary/ideas introduced in section one, they are designed to be returned to again and again. One of my pet peeves about lessons is the presumption that once they're over the learning is complete. Hogwash! Learning is an iterative action. It never stops. As long as you are making marks on the page (even when you're writing words), you are learning to draw.

Even though I've been drawing ever since I could hold a crayon and not eat it, I did all the prompts in this book and learned a lot from the experience. For one, a careful chef tastes her food before serving it to other people to make sure it's edible. More importantly, she becomes a better cook by constantly challenging her own taste buds.

Onward to the meal at hand.

Doodle Prompt

On a sheet of paper (which can be in your notebook or loose or a napkin), draw a square about the size of your palm.

That's it. Baby steps.

Let's move on.

Launch Nerves

When I start to draw on a blank page, I often begin feeling a bit sick to my stomach. This minor (and sometimes major) anxious queasiness fades as I fill the blankness with lines. Over time these launch nerves feel more like speed bumps, annoying but no reason to park the car and abandon my travel plans. The belly ache is usually accompanied by brain voices (back seat drivers), who point out all the reasons to give up—the foreshortening sucks, my perspective is off, shadows are all wrong, and so on. Listening to backseat drivers is a common cause for car wrecks. In my teens, I almost careened off a bridge because I succumbed to advice from the back seat.

You need to develop immunity to your brain voices' seductions of shame.

News flash! Brain voices are easily distracted.

Give your meddlers some delightful music to quiet them while you draw. Promise them a treat if they shut up until you're finished drawing. As the voices recede, a stomach settling beverage, ginger ale, water, or chamomile tea may still be needed to calm your belly. Nibble on a CBD chewy. Get a drink (I don't drink alcohol anymore, but if you're not an alcoholic like me, your drink options can expand accordingly). Breathe. And keep drawing. You are teaching your body and mind to move through anxiety.

This takes time. And patience.

Try some worst-case-scenario ideation. Honestly, the worst thing that can result from you drawing is you make a drawing that displeases you. A piece of paper and a few minutes have been invested and you aren't happy with the results. How is this a disaster? Now, if you had sunk your retirement and a decade of your life into the production of this one drawing, well, it would be a huge bummer that misery overwhelmed you when you gazed upon it. But you didn't. So, stop looking at it. Make another drawing. Try to love this new doodle a little, even if you think it is terrible. Its terribleness is helping you learn to draw. Think of your doodles as toddlers, human masters of teaching patience and love without, in the moment, giving either in return.

Doodle Prompt
Eyes Closed Drawing

I took Lynda Barry's one-day *Writing the Impossible* workshop and we began by drawing with our eyes closed. The results filled the room with surprised laughter. It can be intimidating to sit in a room full of strangers AND famed cartoonist Lynda Barry, much more so to then spend the day writing and drawing. These eyes-closed drawings helped shake the jitters out of us. Barry is so generous with her teaching methods, considers all of them open-source, but I still want to recognize her awesomeness before introducing this prompt.

What you need:

- Paper
- Pencil or pen
- Timer that beeps or a 30-second song

You can return to the square you made, unless you already filled it up with doodles. Or you can make more squares.

Steps to eyes-closed drawing:

1. Set a timer for 30 seconds.
2. Hold a pencil/pen.
3. Rest your hand on the page so the point/nib is centered on the square.
4. Start the timer.
5. Close your eyes.
6. Now draw a cat.
7. Stop drawing when the bell rings or song ends.
8. Open your eyes.
9. Laugh with delight (optional, this might not be your natural reaction).
10. Find something lovable in the doodle.

You can repeat this prompt for as long as it takes for you to feel less anxious. You can do this prompt with dogs, elephants, pine trees, your breakfast, the love of your life, your head, a dancing banana, rocket ship, dragon, a tube of toothpaste and a toothbrush. Anything with physical substance. Make up some of your own! You can draw the same thing as many times as you need. Or never draw it with your eyes closed again. Whatever you choose.

SECTION ONE

Drawing Practice and Techniques

1.0 Introduction

1.1 Drawing Tools

1.2 Line Weight

1.3 Line Vocabulary

1.4 The Diagonal

1.5 Light and Shadow

1.6 Perspective

1.7 Graphic Composition

1.0 | Introduction

You will need a few tools, some basic information on drawing and the opportunity to practice. That's what this section is about. I've broken down the very basics of drawing, beginning with tools, then moving through developing lines, working with light and shadow, and the elements of drawing composition. Think of this section as a drawing primer, giving you just enough to start your adventure, but not packing in so much you feel the weight of it and decide not to bother going anywhere.

1.1 | Drawing Tools

So, paper. You might already carry a notebook with you at all times that you use for writing. If so, try drawing in it too. I write and draw in the same book because having my thoughts in more than one place scatters them. So, the first place to start drawing would be in your daily writing notebook with your favorite writing tool. If this stresses you out, because it feels like your writing space is being invaded, then get another notebook (or a different pen...more on this later). Call this new notebook a sketchbook, daybook, journal, sketchpad, doodle space, whatever you want to call it, so long as the name doesn't create a barrier to you drawing in it.

It's best if your drawing pages are handy at all times and not too precious. I recommend a book with blank pages, though cartoonist Lynda Barry uses lined paper, and lots of architects and mathematicians like gridded paper, so blankness is not mandatory. What's essential is for it to feel lovely in your hands, but not be so costly you fret that drawing badly in it would be an offense to its value. If you have a book that you're afraid to draw in, because you might "ruin" it, replace it. Go to an art store and fondle lots of sketchbooks. Feel the paper. I usually rub a page between my fingers to gauge the thickness and texture of the paper. I like my paper a little thick and slightly rough (call it toothy, if you want to sound artsy).

Also, ink smears on glossy paper and the shiny reflective surface bothers my eyes, so I never use paper with any sheen to it. Hold the sketchbook, imagine drawing in it in public. Size matters. If it's too big, the blank pages will feel both daunting and attract insects on bright sunny days. If it's too small, you'll fill it up quickly and/or lose it.

A key feature of your sketchbook is that it must fit in your purse/bag, so you can draw/write whenever you want. I test the fit in the store before buying the book. Word of caution: always do this in front of a store clerk so they don't suspect you of shoplifting.

What's most important is that you love drawing in your sketchbook. Let the book become an extension of you, not an intimidating version of you, just an any day you.

A you that lets you make crappy drawings all over its pages without ever judging you. That you.

A few words about pens, ink, and pencils. Begin with what you have. You already have a favorite writing tool, try drawing with this. If you find that as you go through the doodle prompts this tool is frustrating you, experiment. Haunt art supply stores and try out all their pens. Find people whose drawings you love and ask them what tools they use.

...Um... is that goose quill?

curvature of

space*

*handy for time travel

My favorite pencil is the Ticonderoga Black #2. There are many other lovely pencils. Pencils are one of the greatest human inventions. They work in space. I've used them

TICONDEROGA® BLACK ⟨N⟩话

underwater while SCUBA diving to make notes. Pencils rock. Find one you love. And by one, I mean, you can draw with just one pencil type. I made all the drawings in my book *By the Forces of Gravity* with my favorite pencil. You don't need every hardness from 9H (like drawing with a nail) to 9B (like drawing with soft butter) to make pencil drawings.

Erasers. Use only as directed. In sketching and doodling, erasers aren't necessary. In fact, emerging doodlers are often cautioned against the use of erasers because they can develop a dependency that undermines their drawing confidence. Eraser dependency is a genuine concern. To avoid it, use erasers in moderation and resist using them on works in progress. Think of them as editors. Both have a purpose, but not while creating a first draft. Be patient and persist through any initial gut sense that your drawing is crap. When the drawing is done, you are free to erase it, but before you do, consider this question: why bother? Erasing takes time and energy you could expend on making another drawing. Or eating a sandwich.

Why do erasers exist? For one, they look and feel awesome on the end of a pencil. In fact, erasability of pencil marks is one of the pencil's oldest and most enduring charms. Henry Petroski notes in his book, *The Pencil: A History of Design and Circumstance*, that when graphite was discovered at Borrowdale, England, in the 1500s, a virtue immediately recognized was that marks made with graphite can be "rubbed out with pleasure."

Emphasis on *with pleasure*.

Erasers aren't for removing shameful mistakes. Erasers exist to help you clean up a drawing after it's done. To remove pencil marks after you've inked over them with a pen. Erasers can be used to sculpt graphite on the page and to make highlights. For these noble tasks, I recommend a vinyl eraser, such as the Faber-Castell or General's Tri-Tip. These erase gently and cleanly without roughing up your paper.

When it comes to ink tools for drawing and writing, I prefer fountain pens. They aren't disposable, feel awesome, and there's a huge variety of ink that works with them. For a while fountain pens faded out of what I would call *the useful realm*. I quit using them for about a decade because they cost a bucket of money and didn't work well in the dry desert air of Arizona where I live. They became over-decorated baubles for collectors. Drawing with them would've been like trying to sketch with a Gertrude McFuzz tail feather. Thankfully, a fountain pen renaissance is upon us and you can find amazing pens for reasonable prices.

I use five fountain pens: three Lamy Al-Stars, the TWSBI-eco, and a Sailor Fude De Mannen - Stroke Style Calligraphy Fountain Pen - Bamboo Green - Nib Angle 55 Degrees (a mouthful for a pen I bought online for ten bucks). I use five instead of one, because each one satisfies a specific drawing/writing need I have. Two Lamys have black ink in them, one with a fine nib and the other extra fine. I mostly use the extra fine, but I like having the other when I need to draw wider lines. All the drawings in this book were made with the Lamy. I use the third Lamy with purple ink for when I write comments on student work because purple is easier to see on a page of black printed text and makes comments seem more friendly than ones written with red ink. I write/sketch with all three Lamys when I need medium lines, the TWBSI-eco when I want super fine lines. But wait, the Lamys have fine and extra fine nibs! What is finer than extra fine?! Pen nib sizes are like clothes sizes where one brand's small is another's medium. Lamy is loose with the term "fine" while TWBSI is tighter. The Fude gives the most variety of line width, great for quick sketching, but too loose for writing.

The Fude pen is fun for loose doodles and will give you a lot of line variety. If you're not in the habit of turning your pen/pencil around in your hand while you write/draw, this is a good one to practice on, because it's light, round and the line varies a lot depending on how you're holding the pen, so you can really get a feel for the value of pen rolling.

Five fountain pens is a bit much, but I love experimenting. In fact, I have to keep rewriting this section because I keep

changing up my list of favorite fountain pens. No matter what, I prefer work horses over glamorous stallions like the uber-expensive Mont Blanc, pens that are affordable, comfortable, functional and refillable. Not surprising, also my criteria list for picking out my clothes.

Fun fact: The Noodler Ahab pen (one I use intermittently) is designed with Moby Dick in mind, from its peg-leg form to its whale-sized ink capacity. The Ahab holds so much ink, you don't have to refill it often, which is great for long grading sessions or taking notes during student presentations (I also use it for faculty meetings, which are long and could use more Moby Dick references to keep things lively). Another perk of the Ahab is its body is made of plants,

not petroleum, and all its parts are replaceable, so it scores high in terms of natural resource conservation, even though right out of the box it smells like strained pea poop in a baby diaper. Not to worry: its scent softens to a slight perfume of talcum powder over time.

For ink, I use DeAtramentis Document Ink, mostly black, but I recently started mixing my own purple, from the same brand of cyan and fuchsia, that has just enough purple to feel fun, but still can seem professorial when I write on a student's score sheet: "Awesome use of contrast. Work on varying your line." I love DeAtramentis Document Ink, because I can watercolor over this ink right away. It dries fast and won't run, unless I'm being particularly impatient and can't wait the 10 seconds it takes to dry before I watercolor. It won't fade or transfer across pages in a sketchbook.

It took me decades to use a colorful ink, and I'm still unsettled about it. I worry about all the new decisions I'll have to make if I let color bleed into my inkwell, that it will compete with my watercolors and require me to either get a hoard of fountain pens (one for each color) or switch to dip pens (the kind Medieval monks used to scratch out manuscripts in dark gloomy scriptoriums and can be easily washed between colors). Neither choice works for me because I can't keep track of a hoard of pens and dip pens make too much noise when I draw with them. My ears are super sensitive, so this noise issue may not bother you. Many cartoonists use dip pens to great effect.

For this book, we will stick to black and white, but I encourage you to explore more ink colors to find what works best for you.

Fun fact: Scientists surmise that newborn babies have monochromatic vision, everything in shades of gray. Maybe it's to keep life outside the womb from becoming overwhelming before they're ready for a full-color world. After a few weeks, color seeps in, starting with red. Eventually, barring color vision variations that keep people from perceiving a full spectrum of color, the whole rainbow appears to them.

Pen and ink final words: what you hold in your hand while writing and drawing your heart out has to feel awesome. Hold the pen, test it out, try it for a while. The pen color, details, weight, size, nib-size matters. So does the ink. I use black ink to limit decision-making when drawing and because I bring color to the page with watercolor paints. Maybe your drawings reside in a rainbow of ink color! Maybe Dragon's Blood or Thunderstorm are ink hues you'll need to tell your stories. Experiment!

Once you have your drawing kit assembled, you can start drawing. Anything. Nothing in particular. Just make marks on the page. You can draw. No doodle squad will come to arrest you for doodling without a permit. There is no permit. Only permission. The permission you need to let yourself go forth and doodle!

Doodle Prompt
Drawing Tools

What you'll need:

1. Pencils
2. Pens
3. Paper (one kind, a variety, or your journal)
4. Permission to play

Preparation:

Have you ever had a cat walk across your page while you're writing/reading/editing? They dance over the work in an effort to seduce you into giving them all the attention you had been devoting to the paper under their paws. **Think of this dance while you fill up a page with squares, about the size of a cat's paw**.

Prompt:

Fill these small funny little kitty paw squares with doodles. For each square, you can play with a specific pencil or pen. You can use the white space around the paws to make notes about how you feel about each drawing tool.

You don't have to draw anything in particular in the squares. Just play with what the tools can do in your hand. Press hard, be soft, try curly lines, go dark.

Try this prompt using different types of paper. Some choices to consider:

- regular bond (plain copy machine paper)
- rough, toothy paper
- newsprint
- lined paper
- a thick paper, such as 100-pound smooth surface Bristol

Make notes in the white space (or whatever color paper you're using).

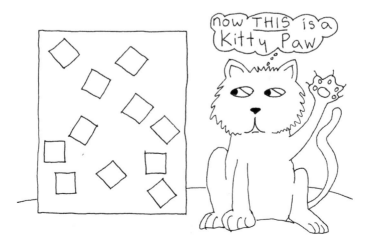

1.2 | Line Weight

Finding your voice in a line.

Proust wrote dense sentences that went on for pages, line after line after line. The word count for *Remembrance of Things Past* is 1,267,069. Kafka's "The Trees" is 45 words, not counting the title.

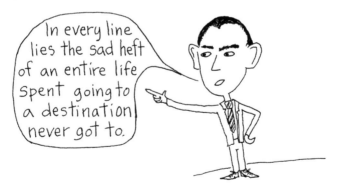

If Kafka was an art teacher

In every line lies the sad heft of an entire life spent going to a destination never got to.

Line density in drawing is like word count. Finding your sweet spot takes practice and attention to your gut response. I'm not talking about blank-page jitters (see Launch Nerves p. xi-xv). The sense that a drawing style is not for you feels more like

dread, as in writing when the voice or word count or literary structure is all wrong, and you know you've got to try another way. How you're 1,000 cross-hatches into a drawing and you've got 50,000 cross-hatches to go and you want to turn and run. That feeling.

Think about this: Not being able to stomach writing a novel doesn't strip you of your writerhood. Rather than hate yourself, consider the likelihood that you're a poet or a flash fiction writer. Maybe short stories are your jam. Same with drawing.

The following poetry fragment is from *Impulse to Draw*, a book by Chip Sullivan and Joe Slusky. They taught drawing together for decades at Cal Berkeley, and I had the sheer joy of being their teaching assistant one semester. Their inspirational book is full of the poetry that spilled from Slusky as he taught.

> The lines you lay down are airborne creatures.

> What is the noise level of your line?

> Every line has a sound level.

> The picture's life is a totality of every line you put down.

What is the noise level of *your* lines? Try drawing with lots of lines. Try drawing with barely any. Try a few line-counts in between. Feel your gut while you're drawing. Go with your gut.

Very important truth: what you enjoy looking at in other people's drawings is not necessarily how you'll enjoy drawing. You may even find it's the total opposite. I love Maurice Sendak's dense and delicate ink drawings. I could look at them for hours (and did as a kid, back when I didn't have to work for a living), but I've tried to draw like him and can't. Everyone has their own drawing voice. Find yours and sing with your lines.

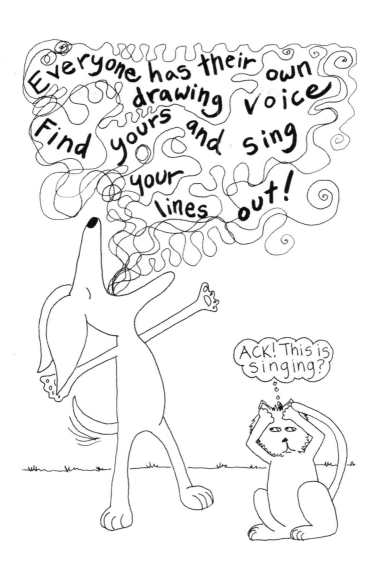

Doodle Prompt
Line Weight

Make a page of cat paw squares (see section 1.1 prompt).
For this prompt, you may want your cat to walk in a super
orderly way to make a grid of squares. In one row, draw a
series of straight parallel horizontal lines that start light and
end heavy. For another row, start heavy and end light. Now try
pulsing between light and heavy and vary the pulses. Notice
how these parallel lines start to vibrate or ripple like water in
a lake.

Varying line weight helps the lines come to life. The pulse
often links to your heartbeat or the rhythm of your breaths. I
usually rest my wrist on its side on the paper so I can use my
arm to gently increase and decrease pressure as I draw the line.
I'm right-handed, so I usually stroke left to right. If you're left-
handed, you might try stroking right to left.

Do the same prompt, but draw vertical lines.

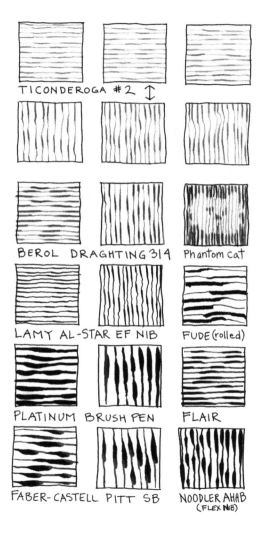

TICONDEROGA #2 ↕

BEROL DRAGHTING 314 Phantom cat

LAMY AL-STAR EF NIB FUDE (rolled)

PLATINUM BRUSH PEN FLAIR

FABER-CASTELL PITT SB NOODLER AHAB
 (FLEX NIB)

1.3 | Line Vocabulary

Voice and breath are inextricably linked. In poetry, line breaks indicate a breath. In prose, it's, commas, that, signal, inhalations. When I draw, I become more aware of my breaths. The lines I lay down on the page keep pace with my breathing. If I want calm still lines, I slow my breaths, which in turn slows my heart rate, which then calms my hand so it can give me the line I need.

More frenetic lines don't require such meditative breathing, but they aren't random or thoughtless. More like controlled chaos.

To develop your range in drawing, it helps to explore the variety of voices you can create with lines. To begin to write, one needs an alphabet. From this, we create words, then sentences, paragraphs, chapters, books, series, a whole dang oeuvre… all beginning with letters. Drawing has a similar kind of primary collection of marks that create your line vocabulary. The cool thing is that you can create your own line alphabet and vocabulary. There's no agreed upon set of 26 marks that make up the linephabet. I smell freedom!

Start with simple marks and build your own voice in drawing, one line at a time. Here are a few line types to get you going. From teaching math and design (for 40 years!), taking art classes, reading drawing books, staring at drawings, and

drawing a ton of lines, I've concluded that the following are good lines to get to know: curvy, jaggedy, raggedy, scribbly, jiggly, broken, parallel, straight, and implied.

Curvy lines are lines that bend, but don't turn corners at an angle or make sharp edges. They feel supple and loose like a line doing yoga.

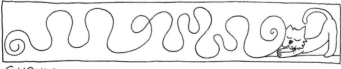

CURVY

Jaggedy lines zig and zag about, making lightning bolts, angry eyebrows, pointy hair and all things sharp and alarming.

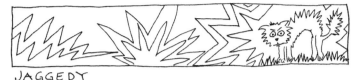

JAGGEDY

A cousin to the jaggedy line is the raggedy line, also called the feathered line. Cousins, yes, but very different lines. Raggedy lines get a bad rap for looking hesitant, but this line can create soft, quiet-voiced drawings. They feel like shyness. Cartoonist Edward Koren makes great use of the feathered line and has been a regular in *The New Yorker*, so don't dismiss the raggedy line's potential.

RAGGEDY

Scribbly lines are made by scribbling, an act of creative abandon that, because it is so fun and freeing, is feared and shunned. To scribble is to let go of years of early childhood training in staying within the lines. Scribbling is liberating.

SCRIBBLY

Of course, jiggly is scribbly's cousin, but is more reserved, less wild. Jiggly lines happen naturally when drawing on a train or subway, but you can draw jiggly lines while sitting still, by trembling your hand a little. I was classically trained in the jiggly line in graduate school because it is a coveted line for drawing landscape plans, but in truth advancing age has gifted me with a more authentic tremble that keeps my lines jiggly. I don't have to fake a shake like I did in school. Yay aging!

JIGGLY

Brokenness usually implies trauma or ruin. Not for drawing lines. I was also taught to break my jiggly line in graduate school, but you don't need an advanced degree to break a line. Just lift your pen/pencil off the page, a micron is all it takes, from time to time. This is applying, with intention, the basic law of doodling that you can only make marks while the pen/pencil is touching the paper. I break the line when I need to adjust my hand or arm.

BROKEN

You may recall parallel lines from geometry. In 10th grade, you probably only met straight parallel lines, A and B, that had something to prove. Well those are just the mathy members of the parallel family. Parallel lines can be curvy, jaggedy, raggedy, broken and implied! The only rule for parallel lines is they can't intersect (which is why I left scribbly out. One can't truly scribble while thinking about keeping the lines from meeting).

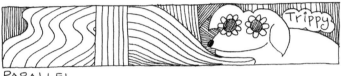

PARALLEL

The straight line is like the 10th grade parallel line, without bends in itself, but you just draw it alone, without its parallel pal. Straight lines are direct, no-nonsense lines that'll get you from A to B fast and efficiently. The easiest way to draw a straight line, without relying on a ruler (called free-hand drawing) is to keep your eye on where you want to end up. Like driving a car, don't focus on where the pencil is, but where it's headed. Forget Be Here Now (r.i.p. Ram Dass). Think Go There Now.

STRAIGHT

The implied line cracks open the line universe. Astronomers have discovered planets not by physically finding them, but by paying attention to the wobble of stars. If a star wobbles, this indicates that it's near some other celestial body. Astronomers point their telescopes not to where they see a planet, but where the star implies, by its wobble, a planet might be. And sure enough, planet discovered! Implied lines use this same principle. If you draw enough hints of a line around where you want people to see a line, they'll see it. Kind of magical. Like monsters in movies that never appear on screen, but still scare the crap out of you with their implication.

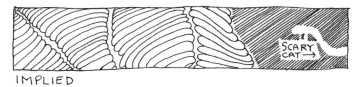

IMPLIED

Alois Fabry noted: "Vertical lines convey a sense of dignity; horizontal lines, repose; curved lines suggest grace and movement; zigzag lines, action." (p. 18, *Sketching is Fun*) Although these descriptors feel gendered in a way that rubs against my grain, it's interesting to consider what lines emote from the page. Study your new linephabet. Note how each line makes you feel, what images they conjure in your mind.

Doodle Prompts
Line Vocabulary

On a blank page, play with each of the lines described in this section: curvy, jaggedy, raggedy, scribbly, jiggly, broken, parallel, straight, and implied. Don't fret about them becoming something. Let them romp around and explore. Experiment with pen and pencil.

On a blank page, focus on a single line type. Draw it over and over again. Repetition helps embed the action into your body memory. Over time, the line begins to link to established paths in your mind that lead to the place where your voice dwells. Over time, like your handwriting, these lines become a part of your natural vocabulary. You can do this with any and all of the listed line types.

On a blank page, play with lines using: zigzags, vertical lines, horizontal lines and curvy lines. Think about the mood or emotions these lines create.

On a blank page—okay, if this *on-a-blank-page-thing* trips you up, close your eyes and make a few quick marks on the page. Open your eyes and explore on this lovely totally-not-blank page your own collection of lines. You can start with the provided line list, but can also let yourself wing off into unknown territory.

1.4 | The Diagonal

On the virtues of the diagonal with stick-figure-you photo bomb.

"Tell all the truth but tell it slant," wrote Emily Dickinson. Why? The answer lies in the rest of her poem that this line comes from. Slant truth has "superb surprise" that "dazzles gradually." Who can argue with that? Not me. Drawn lines can follow similar poetic advice.

The page is a physical space. Drawing is not just about creating an image to look at. It's about storytelling. It's about creating movement. The page comes alive with lines. What you draw follows laws of physics. Heavy things yearn to slump to the bottom of the page. An important law of page physics is that a subject placed smack dab in the center will anchor there, keeping the whole drawing still, like it lacks momentum. This can feel boring. A way to avoid a motionless sleepy drawing is to use a diagonal like a teeter-totter. Give the page a slope for the eye to follow, to let the mind recognize a drawing's physicality.

Of course, for every rule of drawing, there exist wonderous violations of it. Sometimes the drawing you need is one anchored dead center on the page. The key is to do this with intention.

Before we get to the diagonal prompt we need to play around
with drawing the self. You may be thinking: "Wait, what! Too
soon! I just learned the linephabet!" Not to worry: we're talking
stick figures and slight variations on the stick. There are references
in the back of this book for more ways to draw people. For now,
we'll focus on creating yourself as a cartoon stick person.

I'm neurodiverse, in the sense that when I read *Aspergirls*
by Rudy Simone, I recognized myself on every page. Also,
a therapist once told me I had a hint of autism, like it was a
spice used to flavor my life. Whatever my neurology is called,
my brain wiring is no doubt what has made me a scholar of
human faces. I draw people all the time, perhaps in an attempt
to decipher expressions since I wasn't born with the full
codebook on what facial expressions mean.

When drawing people, even those made mostly of sticks, I begin with the eyes because eyes are the most direct portal into a person's mind. They express emotions, give clues about where the action is on the page and, because eyes come in pairs on humans, they're great practice in drawing with bilateral symmetry. Once the eyes are on the page, then I draw the rest of the head. I'm partial to heads, so they get the most details for my stick people. Here are some eyes to try drawing:

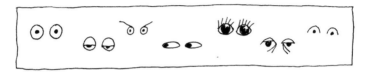

Fill a page with eye pairs. Next to all eye pairs on your page, write whatever sense you get from them.

From your page of eyes, pick a pair of eyes you like. Draw a circle/oval around them. Below the eyes, make a mark for the nose. Here are some quick nose marks to try:

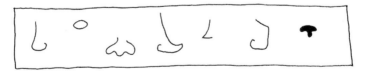

Under the nose, make another mark for the mouth. Like the eyes, mouths say a lot—too much sometimes. Play around with drawing mouths and, as with the eye pairs, write the feeling you get from them.

Here are some sample mouths:

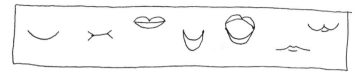

Pick a mouth from your page of mouths and draw it below the nose. On the side of the head, about where the eyes are, make two little scoop marks. Call them ears, move on.

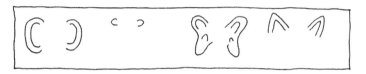

Ok, hair. Another fascination of mine when drawing people is hair. Hair (and glasses) can capture a person's likeness so quickly. I was born with super boring thin limp wispy straight dustpan brown hair, so I have altered it many times throughout my life. My cartoon avatar (stick or full-bodied) changes her hair when I do. Here are some hairdos I've sported over the years:

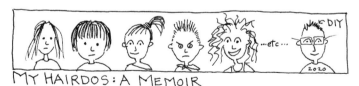

MY HAIRDOS: A MEMOIR

Draw a page of circles and put hair on all of them. Pick a style you like and draw it on the head you've been building. Ta-da! You have a head!

If you want your stick self to wear glasses, draw the frames and make a flick mark on the side of each frame, and a tiny bridge between them. Here are examples of glasses I've worn over the years:

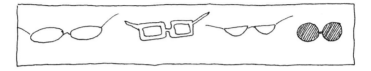

Bodies can be drawn quickly. This is the main purpose of the stick person, to be drawn quickly. You'll need a neck, torso, legs, feet, and arms. We'll get to hands after you pick the rest of the body parts. Here are some quick bodies to try drawing:

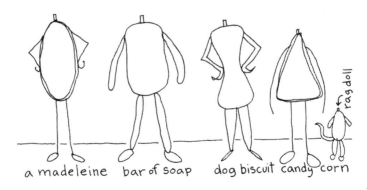

A few potential body models you might have laying about

a madeleine bar of soap dog biscuit candy corn rag doll

Pick the body that you enjoy drawing quickly and draw it under the head you just created. A few words about feet. Cartoonist Eddie Campbell says: "Make sure you draw a pair of feet on every page." Sound advice. Feet keep a story moving. For now, you can let your doodle self have simple feet, little ovals at the bottom of your legs.

Ok, hands. In *The Book of a Hundred Hands* by George B. Bridgeman, he begins with this observation: "The face is well-schooled to self-control as a rule, and may become an aid in dissimulation of thought and feeling….Rarely is the hand so trained; and responding unconsciously to the mental states, it may reveal what the face would conceal." Indeed. Think of a magician's use of sleight-of-hand. Magicians capitalize on how preoccupied people are with faces and talking mouths, while their magic hands are busy sneaking doves out of a coat sleeve. Bridgeman wrote a whole book on drawing hands because they are such an essential part of the human body and so darn tricky to draw.

Hands. Hard to draw. Handy to have. How to tackle this conundrum?

You could do what many new cartoonists do and keep your stick characters' hands in their pockets. Imagine watching a movie in which all the main characters keep their hands in their pockets the whole time. This might work for a noir avant garde French film, but otherwise would be a real snoozer. Jack Hamm writes in *Cartooning the Head & Figure*: "One doesn't have to travel far to find hands. They're ever before us.

Why, then, the difficulty drawing them, even in cartoon? The reason is these five-digited instruments can assume so many shapes and do so many things—and that is well." He follows this comment with 393 examples of hands doing stuff. Your characters need to do stuff, so let's get them some hands.

A hand has almost 30 bones and its own fancy features like the *anatomical snuffbox*, but in their simplest reduction, a hand is a disc with five tubes protruding from its edge. On a stick person, depth is not so important, so this form becomes a circle and five ovals. The ovals are bendable, but for starters, they can stay straight. The finger ovals are at the top of the disc and the thumb oval attaches at a distance from the four finger ovals down near the bottom of the disc. When straightened, the thumb is at a right angle to the fingers. Here are some sample hands:

Play around with drawing hands, pick a pair that you like, one left hand and one right (distinguishable by thumb placement) and draw it on the end of each arm on your stick person.

Yay! You now have a person!

Doodle Prompt
The Diagonal: Drawing it Slant

Selfie Comparisons

Make two rectangles (portrait orientation) on a page. They can be about the size of a cell phone screen.

In one rectangle, lightly draw a vertical line down the center. You can draw the line in pencil and then do the sketch with a pen, or practice your line weight skills and use only pencil or only pen. In the other rectangle, lightly draw a diagonal from two opposing corners.

Set your timer for three minutes. In each of these rectangles draw a selfie. You can use your new awesome stick-self and add trees or whatever you like as surroundings. For the rectangle with the vertical line down the middle, draw yourself centered on this line. For the diagonal, you can draw yourself on the diagonal or contained completely within one of the triangles that the diagonal makes. Feel free to throw an arm into the other triangle, but most of your body will be within the triangle or out of the picture.

Study these selfies. Make notes beside them about how each one feels. It's not that one is better than the other, but that the two compositions are dynamically different. You can use this difference with intention.

1.5 | Light and Shadow

One of the great gifts of drawing is that it allows you time to study the world around you and to begin to understand the nature of light. When we look at an object, our eyes don't see the object, they grasp the light that bounces off its surface. Think of the phrase, *to catch a glimpse*. *Glimpse*, in the family with *gleam* and *glimmer*, derives from an Old English term for *shine*: an action of light. Our eyes grab the light, process it into neural signals that continue further into the brain. The object's form, color, and texture are then reconstructed for our mind's eye based on the nature of the light reflected from the object. To draw what you see is to try to replicate this process, to trick the eye into thinking it sees the light bouncing off a fluffy kitten when, in fact, it's looking at pencil smudges on paper.

You can become a better eye trickster if you study light.

Leonardo da Vinci was an obsessive observer of light and noticed that "between the shadows, there are other shadows." Don't fret. You don't have to be da Vinci to see the depth of shadows.

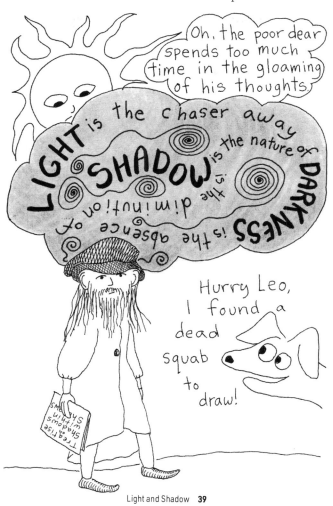

All the time you've spent outside or in the company of light bulbs has given you ample experience to begin adding shadows to your drawings. To help you build on this experience, here are a few brief facts about the physics of light as it pertains to drawing.

Don't stare into the light. It can be blinding. Look, instead, at light slantwise. Study how it falls on objects. How it disappears in dark corners. Light travels 186,000 miles per second, faster than anything in the universe, but it bangs around a lot during its journeys and it is light's bumpy ride that merits attention when drawing.

Put an apple (or orange, oak gall, anything smooth and roundish) on a table near a slant-light source. Look at how light bounces off the table and under-lights the apple. This is reflected light (versus direct light).

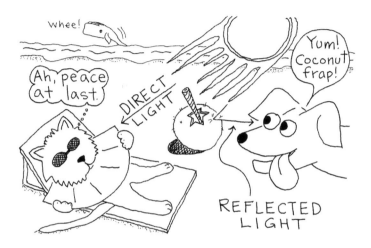

Put a straw (or fork, pencil, anything straightish) in a glass of water and set it on the table. See how the straw seems to shift at the surface of the water? The straw isn't bent or broken. It remains straight, but the light bouncing off the straw bends when it moves through water which alters its speed before reaching your eyeballs. Your brain interprets this refracted light as a bend or break in the straw (brains try, but they don't get everything right). This is called the broken pencil effect and is useful to keep in mind when drawing reeds growing up out of a pond or sketching a portrait of yourself in a bathtub.

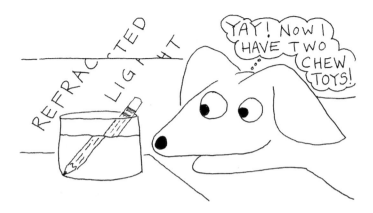

Return to the apple. Study where the shadows fall. Where shade is cast. Move the apple around and pay attention to the movement of both shadows and shade. Light doesn't stand out without darkness. As Bob Ross often noted while happily painting on television in the 1980s: "We put some dark in, only so our light will show. You have to have dark in order to show light." Drawing with a gradient of light to dark is super helpful for making an image appear three dimensional, for creating atmosphere and contrast. Betty Edwards, in *Drawing on the Artist Within*, calls the attention to light and shadow *light logic*, noting: "Perhaps light logic in perception is equivalent to setting in language, which establishes mood, tone, and a sense of reality." I love Edwards' expansive perspective on drawing and the idea that light has logic, but I prefer to focus on the physics of light. This way I remember the physicality of light beyond the mind, how it bends and bounces, gets muffled in fur.

Light and Shade: A Classic Approach to Three-Dimensional Drawing by Mary P. Merrifield is filled with lessons about the relationship of light and shade, most of which sound like literary tips or aphorisms for life:

> "The darkest parts of shadows are on their edges."

> "Light appears brightest when it is surrounded by the greatest quantity of shade."

> "Lights are less modified by distance than shadows."

> "Shade exists when a surface is turned away from a light source."

The link between light and language has a long enough history to fill six pages of the *Oxford English Dictionary* with definitions of shade and shadow, including:

> "the sadder portions of a person's history"

> "gloom, unhappiness"

> "a temporary interruption of friendship"

> "an attenuated remnant; a form from which the substance has departed."

Easy peasy to dash off a poem from these melancholy prompts that seem straight out of Kafka's diary, but how to draw this?

With tone and hatching.

Tonal drawings work in the gradient of light to dark. Tone functions a bit like sentences and paragraphs, or as Arthur Wesley Dow puts it in his textbook, *Composition: Understanding Line, Notan and Color*: "Line melts into tone through the clustering of many lines." Consider how words, when clustered together, become sentences and paragraphs. You have already been exploring lines and are well-versed in sentences and paragraphs, so your leap to tonal drawing will not be without a net.

Hold a pencil in your hand so that you can comfortably rub graphite from the side rather than from the point. Make smudges on paper. You can vary the darkness of your smudges by varying the amount of graphite you rub in any given spot of the page. More rubbing makes more darkness. Here's a time when you might want to experiment with a soft pencil, like a Berol Draughting 314 pencil, a 4B or 5B pencil, or even a hunk of soft graphite. The softer the pencil, the easier and smoother the graphite sheds onto the paper. Try to develop a gradient from light to dark. Alois Fabry calls drawing in this way *pencil painting* (have I mentioned I love Fabry?).

Pencil smudge↑

Unlike pencils, most pens are designed to render a reliable thickness in line, so they don't smudge well. Enter hatching. Hatch marks are lines drawn close together, most often parallel short line strokes of the same length, but this is not a rule.

If you hatch some lines and then hatch some more lines across the top of these lines, you're cross-hatching. You can create tonal variations by altering the closeness of lines and the number of times you cross-hatch. Hatching feels like sculpting with darkness and light. Like the Zen practice of sand raking, hatching can be very relaxing.

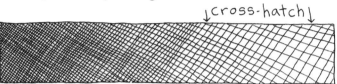

↓cross-hatch↓

Now a word about Scribble and Stipple. No, this isn't a Vegas singing duo, just two more ways to go dark. Scribble is what you do when you let your pencil/pen move in small shaking paths. It's a great way to fill space when you don't have the time or patience for hatching. Start at the edge of a drawn line and just move your pen/pencil in a shaky way. Practice varying the tightness and looseness of the shaky path. As you fill the page, you can return to places already scribbled over. Try to create a gradient from dark to light.

Stippling is treating your pen like a tiny jackhammer. Pens stipple better than pencils, but use a pen that won't get ruined by the continual tapping against the page, so not your fountain pen, if you can avoid it. Rest your wrist on the page, hold your pen perpendicular to the page, and repeatedly bounce your hand so the pen creates dots. Try to make dots versus little comets with tails. Do this a million times, while minutely moving your pen around. Vary the distance between dots to

create a gradient from dark to light. The amount of stippling depends on your available time and patience. It requires ample dot density to create a sense of shadow. If the dots are too far apart, it'll just look like whatever your drawing has chicken pox.

So now you have four ways to fill a page with darkness: pencil smudging, scribbling, hatching, and stippling. I listed them in order of speed from fastest to slowest, so you can choose accordingly when sketching.

scribble↓　　　　　　　　　　　　↓stipple↓

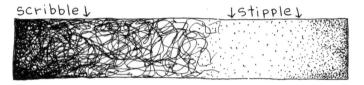

The study of light, shade, and shadow relies on looking at the world around you. This might make you feel like you have to draw what you see realistically. That's akin to believing you always have to write what you see realistically. As though you're not allowed to interpret human experience with your imagination. So, fiction is out. And speculative memoir. Most poetry. All writing, in fact, except perhaps instructional manuals. Consider this. Everything you see is already an interpretation of light bouncing off surfaces, so what's the harm in extending the interpretation? The purpose of looking isn't so you can draw with photographic precision; it's to help you understand the nature of light, of substance, of materiality, so when you draw (and write!), whether it's the tree in front of you or an imagined place, your drawing feels believable to you (and your audience, if you choose to share your drawings with other people).

Doodle Prompts
Light and Shadow

Still Life Tonal Drawing

This can be done outside in the early morning or late afternoon, inside by a lamp, or near a flickering candle for a goth feel. You want to have slant light. Make a tonal drawing of the scene, focusing on light and shadow. If you're inside, you can set up a still life. Pick smooth, opaque upright objects, so the bounce of light is clear and the shadows are prominent. You can take a picture of the scene and play with the contrast to help you see the light and shadow. Don't fret if what you draw doesn't look like what you see. This drawing is a study of light and shadow, not an exercise in photo realism. You have the photograph for that.

Scene Tonal Drawing

Go outside on a sunny day (not at high noon, but when the shadows are long and slant). Find a scene that interests you and sketch it. Pay particular attention to the shadows, how they cascade down a stairway, how they drape across a chair. Consider where they are deepest and how they fade to light. Try not to rely only on lines to define what you're drawing.

Use tones. It can be helpful to use a soft pencil that has no eraser (so you won't be tempted to revise while drawing). Try working from light to dark. Then draw it again, starting with the dark regions first. And yes, this is a metaphor for storytelling.

Dark Shadows

Take a simple object and set it near a lamp or candle. Sketch it using whatever kind of lines you feel like using. Focus on the play of light and shadow. Draw the object multiple times until the page is full of shadows (and shadows within shadows), keeping it fresh by varying the object's position in relation to the light source, line type, size of drawing, and pencil/pen.

Filling Space

Make shapes on a page and fill each of them with a different shading technique: hatch-marks, cross-hatching, scribbles, and stippling. As you fill the spaces, think about varying the sense of light and shadow.

Warhol Contrast

Draw four squares, like a cat-paw box grid. Inside each square, draw your portrait. You can also draw an object (soup can, perhaps?), if you don't feel like doing a selfie. In one box, use one of your darkening techniques to fill the background with darkness. In another, leave it blank. In the remaining two, darken the background to two different shades between the dark and light you did in the first two squares. Notice how varying the surrounding affects the feel of the portraits.

Addition and Subtraction

Make a tonal drawing. This can be a still life, a scene, a portrait, whatever you want so long as the play of light and shadow is significant. Use your eraser to pull out highlights (those little places where light bounces off an object in such a way your eye just sees white light) Shift back and forth between laying down darkness with the pencil and pulling it off with the eraser. Think of this as sculpting. This can be messy, like making mud pies. Revel in the mess. Focus on the light and shadow.

1.6 | Perspective

Maybe it's my quirky brain wiring, but I've always struggled with perspective. From the start, my drawings have placed my point of view up in the air. I wasn't drawing what I saw from the ground. I was drawing what I'd see if I were a bird in flight. This is a common tendency of emerging perspective drawers, most of whom eventually land on the ground. I never did. I used to feel ashamed about it and get all pissed off every time I tried to construct a drawing in three-point perspective. I would totally forget to channel my inner Fabry. Now that I have the gift of philosophical perspective, ripened by time passing, I'm at peace with my loose grip on vanishing points, lines of sight, and picture planes. What I delight in is playing with perspective to create emotional depth.

The *Oxford English Dictionary (OED)* acknowledges this venture into emotional depth as its own kind of perspective, in that it is "penetrativeness."

I caution you from trying to construct a perspective, using a 3-D grid, too soon. With time, you may want to give it a go, especially if you're into technical calculating. If you naturally create an outline and map out your writing projects before you start writing, you might enjoy the precision of the constructed perspective (I've referenced some books in the Tail End section

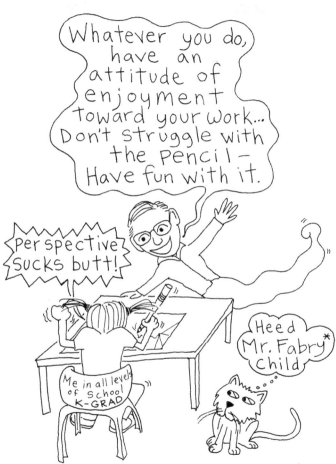

*Alois Fabry taught me this with his books

of this book that can help you). If you prefer to jump into the writing like it's a wild and scenic river to see where your word flow takes you, these basic concepts should keep you afloat.

Perspective in drawing is akin to point of view (POV) in writing. A few rules have solidified ever since perspective drawing gained mathematical precision in the 15th century. In this table, I've shared these rules—and their aligned literary POV counterparts:

Perspective Drawing	Literary POV
Things appear smaller, the farther you get from them.	Write less about distant subjects.
Things appear fuzzier, the farther you get from them.	Be precise with details when your POV is close.
You can't see through opaque objects, so a nontransparent object is closer to you than whatever object it's blocking from your view.	You can only write about what you can see, so move the POV if it doesn't give you the view of the scene you need.
Drawings have 1, 2 or 3-point perspective and the points that everything recedes into are called vanishing points.	Not the same, but similar to first, second and third person POV, in that first person can't give you as many POVs as third person can. And 2nd person POV is everyone's wild auntie who does whatever she pleases. Way more interesting than visual 2-point perspective, which is just drawing objects so they vanish on the horizon at two points instead of one. Snooze.

If you want to give the illusion of depth, the key element of perspective, it helps to have a horizon line and some similar shapes drawn at different sizes, the bigger ones blocking some of the littler ones. Think, as well, about the structure of a basic composition with its beginning, middle, and end. In visual composition, this translates to foreground, middle ground, and background.

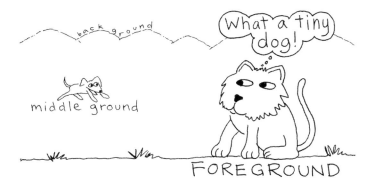

Draw some stuff up close. Show the details. Use crisp lines. Draw some stuff way off in the distance. Make them small and fuzzy, like what things look like when they're far away. This is where the horizon line dwells. It can be flat like the horizon formed by the ocean or bumpy like a distant mountain range. The more you shrink and fuzz up the background, the vaster space you'll create on the page. Between the foreground and the background, lies the middle ground. Whatever you draw there needs to be proportionately smaller than what's in the foreground and larger than what's in the background.

It's not necessary to follow any of these rules of perspective when drawing. Plenty of great drawing existed before perspective was discovered, so if drawing in perspective gives you a pain in your brain, don't do it, or find comfort in being wonky at it like all the Medieval illustrators were. Even without perspective, it's clear from my redrawing from a Medieval Bestiary that a Bonnacon has prodigious farts.

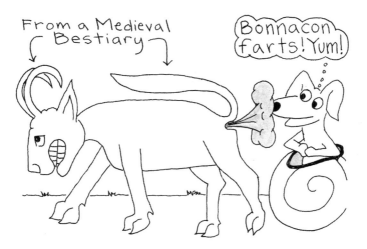

Now that perspective drawing is old hat, people tend to expect it. People expect a lot of stuff they don't need. If someone looks at your drawings and says, "You have the perspective all wrong," simply reply, "not from my point of view." Or lecture them on the magnificence of Medieval illustrated manuscripts. Or say nothing, just keep drawing, smiling enigmatically.

I will end here with a brief discussion of foreshortening.

It's real.

It's a bitch.

Point long things in your face and draw what you see and NOT what you know is hiding behind the little pointy tip… such a tiny tip…hiding so much.

Doodle Prompts
Perspective

Redrawing

This exercise can help you get the hang of drawing objects at different angles, which can in turn help you get a feel for drawing in perspective.

In your notebook, copy the following drawings of simple objects, drawn from a variety of points of view.

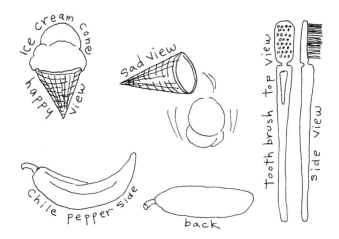

Minimalist Landscapes

You can do this outside, if you live in a place that isn't too visually complex—a house boat on a quiet lake, by a train track, in the desert near a few cacti and a distant mountain range. If not, you can also find images in magazines or online to work with. Do an online image search using words strings like: train simple perspective landscape. Swap out *train* for *road*. Pick scenes that you like, but that aren't filled with gothic cathedrals or other complicated architecture. Less is more when learning to draw in perspective. It's easiest to start with one-point perspective.

Begin by drawing a rectangle in landscape orientation. Draw in the horizon line, faintly at first. Locate the vanishing point (the place everything recedes into).

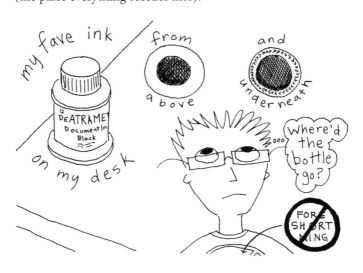

Don't try to draw all the details, instead focus on the shapes in the landscape. This isn't an exercise in learning to become a landscape illustrator. It's training for the eye and hand (and all the wiring that connect them to your brain).

After you feel confident about your roadway and train track drawings, try more complicated places and images. If you get in over your head, just return to the simple landscapes. If you really love buildings, try drawing early modern ones, like Villa Savoye, the Farnsworth House, or some Bauhaus structures, so you don't get overwhelmed by pre-modern decoration or the wackadoodle digitally fabricated building forms that are all the rage these days.

1.7 | Graphic Composition

Fundamentals of composing a page.

In writing, there is the story: something happens and it gets told. No! Remember the rule, show don't tell! Okay, something happens and it gets shown. In writing, the magic comes in crafting the story, shaping the language, the length, structure, the weave of time. The magic comes in composing the reveal. Same for drawing.

So far, we've been exploring all the ways to make marks on a page. You've developed a linephabet, played with ways to go dark, to draw slant, and gained a little perspective. Now we'll consider a few principles to help you put all these marks together to create a composition. Recall from childhood, how after you had a grasp on words, sentences, and paragraphs, your teachers started asking you to write compositions. You were probably told they all had to have a beginning, middle, and end. True enough, if you're working in linear narrative. Composing a drawing has no such linear limitations, even if the whole thing is composed of lines! Think of a drawing as a lyric essay or a poem, where the structure allows for content and time to come from many directions.

Think of it like jazz.

Here's an interesting phenomenon of composition that holds true for writing, playing jazz, and drawing: what might be perceived as chaos often follows foundational rules. Lyric essays may be braided, hermit-crabbed, follow the pattern of waves or spirals. Poetry, even free verse, leans on so many formal and tonal devices—enjambment, alliteration, cadence, synecdoche, end-rhyme, to name a few—to create a sense of space, sound, and image on the page. When you learn the rules, you begin to notice them more in a composition. You can begin to use them or break them with intention. For years, I've listened to my son learning to play jazz and have come to appreciate its complex structure. Jazz used to sound like random notes to me, but now I hear music.

Learning to draw can feel like this, like you've plunged into a big ocean of visual jazz and have no idea how to keep from drowning. Your life preservers are the principles of composition. Which specific principles are fundamental to visual composition is debatable, but these—balance, contrast, hierarchy, juxtaposition, proportion, symmetry, repetition, rhythm, and unity—can get you started when applied to what you've already explored with your pals line, tone, diagonal, light and shadow, and perspective. All of it together reveals your visual voice.

This may seem like a big cast of new characters, but your writing chops can be readily applied to composing a sketch, a page, or a sequence of drawings—you have already worked with these principles in writing scenes and structuring paragraphs, poems, and chapters of words. While it's helpful to play with these principles in isolation, to get to know them better as visual devices, you will eventually apply them in concert. For starters, the composition principles can clump together into three categories: harmony, emphasis, and movement.

A few words about beauty. Keats equated beauty and truth, which is an awesome sentiment that gives weight to authenticity over aesthetics, but he also claimed "that is all/ Ye know on earth, and all ye need to know." It helps if ye know a little more when composing a drawing. I like to think about what Alberti said about beauty, how it's reached when you arrive at a place where there is nothing more to add or take away without diminishing the work (be it a painting, a poem, or a plate of pasta). It's the Goldilocks principle of just-rightness. This kind of beauty transcends aesthetics to include the purpose of a drawing, how it makes you feel, what it conjures in your mind, what it helps you remember, all important attributes that can feed your writing life, much more so than simply what your drawing looks like.

You're the one holding the pen, so you get to decide when a drawing is just right. It can take a bit of practice to discover your own version of done. The principles of composition exist to help you figure this out:

Harmony. Everyone has their own sense of harmony. Balance, symmetry, proportion, and unity, as concepts of harmony, strive for a sense of fit. Not to fit according to some grand metric for what art is, but to achieve fit among all the marks you make on the page. A fit between the maker and their marks. And, if you share your drawings with other people, a fit with your audience's sense of harmony.

When thinking about balance, it's helpful to consider a seesaw. The beam need not be set evenly on the fulcrum.

A large weighty object can balance with a small light one, if the beam is set right.

Visual symmetry is a specific subset of balance that happens when the fulcrum is at the center of the drawing (for radial symmetry) or the centerline of the drawing (for bilateral symmetry).

Proportion is balance as it relates to size. To say that objects in a still life are well-proportioned, means that, size-wise, the fit works. The bananas look just right compared to the apples. Proportion and perspective are interwoven. If you draw an object and keep its proportions and draw it smaller, it will look like the same object, but farther away. As with perspective, you can mess with it to convey a sense beyond appearance.

harmony

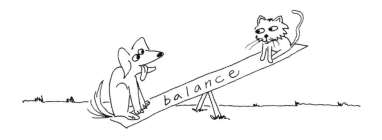

balance

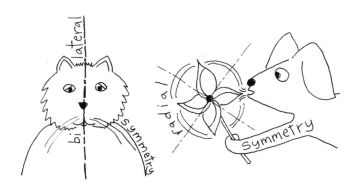

lateral

bi

symmetry

radial

Symmetry

Unity. When I think of this word, I always see The Dude in *The Big Lebowski*, explaining how the rug "really tied the room together." Unity is that feeling of everything fitting together, which is not the same as sameness, even if sameness pops up as a synonym for unity. To compose a drawing that has unity is to ensure that it has a rug in it to tie it all together. The rug can be lines or forms repeated, or voice/tone used consistently—whatever helps to stitch the drawing together, to make it feel cohesive.

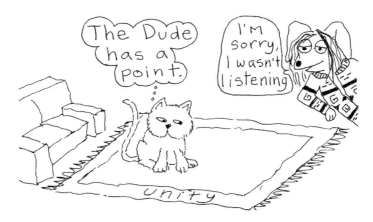

Emphasis. Contrast, hierarchy, and repetition can all influence what is emphasized in a drawing. In pencil/pen drawings, contrast comes with the play of light and shadow, and from varying line weights. Contrast is a way to call attention to a subject in the drawing. Like emphasizing the meanness of one character by surrounding them with super nice characters.

You can also emphasize a subject by drawing it bigger than everything else (hierarchy) or drawing it over and over (repetition).

Movement. Drawings have movement, for one because people look at them with their ever-moving eyes. People tend to scan drawings the same way they read words on a page. In cultures where words are printed from left to right and top to bottom, people tend to scan a drawing this way. But this is not a hard and fast rule. If a word is printed in a **bigger font** or made **bold** (hierarchy and contrast), people will read that first, then scan the page. When people look at a drawing, they are looking for similar cues to guide their eyes. Darkness, bigness, and repeated forms all catch the eye and indicate how the eye might move about the page.

Movement also refers to what happens when light bounces off a drawing and into the eyes, setting off an explosion of neural signals in the viewer's mind, flaring up memories, emotions, waking up the body. Just as a mystery writer sprinkles clues in a story to make the final ah-ha moment a thrill for the reader, you can apply principles of composition to make the conversation between the drawing and the viewer more engaging. Even if you are the sole viewer doodling in your sketchbook, you are conversing with what you create on the page. Composition helps make it a dynamic conversation.

You can work with these composition principles to create a drawing that is still and quiet, or you can, with intention, compose an image that feels off-kilter. Remember, the laws of physics apply to the page. Gravity exists there. Dark lines feel heavy and yearn to drop to the bottom of the page. Even in a drawing of a still life, the image can have dynamic movement. Two objects drawn beside one another (juxtaposition) create resonance. They vibrate energy, by their sameness (repetition) or their differences (contrast and proportion).

As with writing, it is often during revision that you adjust the composition to bring it closer to having balance that feels right, or enough contrast to convey what you want the drawing to convey. When repetition is just enough, but not too much. You know what I mean? Should I say this again? One more time?

Revision is as essential in drawing as it is in writing. For revision, I often photocopy a drawing I've made, increasing the darkness levels if the drawing is in pencil so the drawing

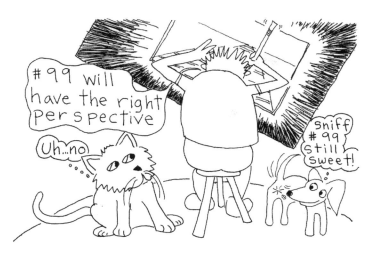

will be readable on my light tablet. You can use trace paper when redrawing or use a light box to illuminate your work for tracing. Or just draw the drawing again. Repetitive drawing, with/without trace paper or a light box, is a way to refine the drawing. Just like revision in writing.

Doodle Prompts
Graphic Composition

Emphasis

Pick an object that is in a story you're writing and draw it. Consider the details that matter most to the story and draw these with more emphasis, use more lines to render these details, and let the rest remain sketchy. Details influence pace in writing, they cue the reader to what matters, so this exercise can help you suss out what to render in detail in a scene and what to leave out.

Music Doodles

Put on music and doodle to the sound. This can be easier if you use instrumental music so your brain doesn't get tangled up in the lyrics and you end up drawing what the song is about. This is a good warm-up exercise for writing. Like with free-writing, the music loosens up your mind and by doodling to the sound, you can reach into the synesthetic sensorial part of your noggin. Experiment with different music. Jazz, classical, and old school rock work best for me. Keep the principles of composition in mind as you doodle.

Emotional Drawings

Read an essay, article, or a passage in a larger work. This can be your own writing, or someone else's work. Draw how you feel about it. Don't draw what it's about: focus on the emotional or sensorial impact the work made on you. This is a kind of reverse ekphrasis. Afterward, you can note the piece you responded to and write some words, but let the first response be visual. Keep the principles of composition in mind as you doodle.

Do this same exercise for physical objects, characters, or places in your story. Don't fret about or draw what a character looks like, rather how they make you (or how they make another character feel).

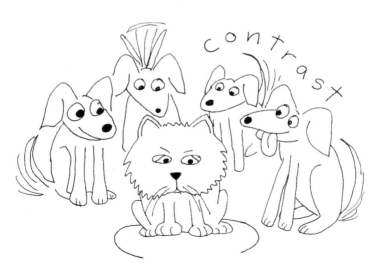

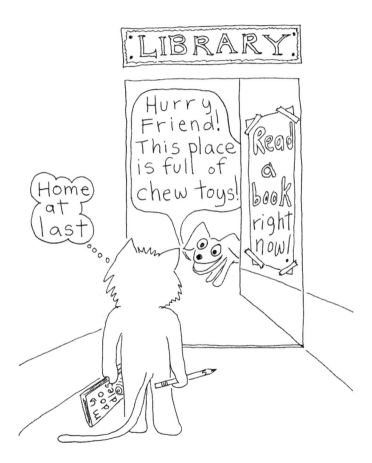

Drawing Application in the Writing Process

2.0 Introduction

2.1 Character Sketches

2.2 Character Accessories

2.3 Drawing to Learn

2.4 Drawing When Blocked

2.5 Mental Maps

2.6 Place Maps

2.7 Visual Shorthand

2.0 | Introduction

Congratulations! You have advanced to the second round of doodling for writers.* Application! I love process. When I studied math, I rarely gave a crap about what X ended up equaling. How I got to the solution was my joy, especially if it required lots of drawings and the use of logic. As a poet and writer, same thing. Even making this book has been awesome, although I'm also happy with the outcome. So much more satisfying than knowing that X=3. A writer's process fascinates me, though it is not as easy to find as their published work. One of my main interests in making this book, second only to wanting to spread the glee of doodling, is to encourage writers to include drawing in their writing process. So here goes!

Section Two introduces ways that drawing can be used in character and scene development, navigating through stalled writing, mapping out story structure, and refining and organizing a story's geography. As with the first section, there are snack-sized subsections, each with their own set of prompts.

Or, perhaps, you jumped ahead, which is totally in the spirit of this little book. Section One will still be there for you if you find you need to shore up your doodling skills, so you can, for example, map your character's neighborhood.

The snacks are smaller bites in this section because you are a writer, so I know you are already filled up when it comes to the writing process and don't need me to tell you how to develop one.

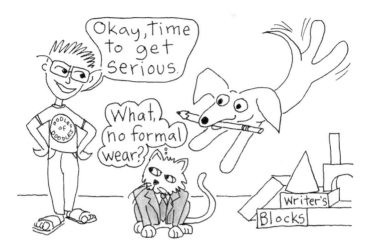

2.1 | Character Sketches

It can help to draw your characters. Comics artists use a *model sheet* that Scott McCloud calls a character "blueprint." The sheet shows the character facing forward and in profile, wearing clothes they would wear and carrying a few accessories important to them. If your character has a pet, draw the pet. The model sheet can also have close-up drawings of the character's head. They can be made for every character in your story, or just the major ones. You can pin them up in your writing space or if you are a nomadic writer, you can do all of your character sketches in your notebook. Like keeping pictures of your loved ones at work, these sketches help you stay connected to your character as you write.

While I was writing *By the Forces of Gravity*, my rough pencil sketches of 12-year-old me and my friend Luna stayed pinned on my wall above my desk. They stared at me for years, reminding me of being a kid, of our scarves and patched pants, of our friendship. I ended up redrawing them and using them in the table of contents pages for the book.

Even if you are drawing your character as a stick person, consider how they stand. Body language can speak for the

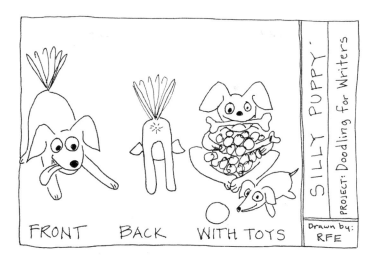

FRONT BACK WITH TOYS

SILLY PUPPY

PROJECT: Doodling for Writers

Drawn by: RFE

character, when their mouths can't say *I love myself, I'm so sad I'm melting into the earth, I feel shame, I love life.* You, as a writer, can also write words next to your character sketches.

This is very brief, not because characters warrant brevity, but because I have a feeling you already know a lot already about character development. All I'm adding is the idea that you can draw them. Enough said, draw!

Doodle Prompts
Character Sketches

Character Development

Draw what your character would draw (how meta).

Go to the kind of place your character would go and draw what's there (unless you write fantasy sci-fi, in which case, go to the closest place that exists on earth and embellish the drawing). Draw what stands out to you the most. These can become the details in the scene you write. Make notes as thoughts come to you. Note what you're drawing in case you look at it later and can't decipher what you've drawn.

my fears

about Covid-19

Character Sketches

Draw model sheets for your character(s). Draw a front view and side profile, a few head shots with characteristic expressions. Pick out a few outfits (or clothes for characters that don't wear outfits). Draw each character to the same scale, so you can see how their shapes and sizes compare. You can pin these up around your writing space when you're done.

Expressions

Make a grid of circles or ovals in your sketchbook. Now draw different facial expressions in each shape—angry, sad, coy, perplexed, bored, happy, furious, depressed, shy, surprised, worried, thoughtful, shameful, disdainful, terrified, suspicious, love-struck, amused. You can do this with particular characters in mind, using the facial expression they would use.

2.2 | Character Accessories

The fragment of a William Carlos Williams line—"no ideas but in things"—sits on my windowsill along with 122 of my favorite tiny objects, including a wiener-mobile whistle, the shed exoskeleton of a grasshopper, Australian sand from my shoes, an origami narwhal, Cerberus, and my daughter's handprint from 2001. Things matter. What a person surrounds themselves with is a form of self-expression. Even if a person is a minimalist. The absence of things cluttering up their surroundings speaks to who they are.

Jack Kerouac's sketch of what a person on the road, living on 50 cents a day, would carry includes books tucked under his arms, gloves in his pockets, a roll and camp kit on his back, holding a lantern, and at his feet the roll is opened out to reveal a blanket, more books, a notebook, rope, machete, brush, raincoat, zipbags, food. Under the drawing is a numbered list of items, calling out book titles (the Bible, Thoreau, Buddha, and Shakespeare), fish hooks and line, a manuscript, pencils, shave blade and soap, altogether seventeen categories of essentials to live for "100 days or more" on fifty dollars. Fifteen actually, since he scratched out two (11 and 12) and I will forever wonder what he rejected.

What would your character pack in their vagabond kit? Or display on their windowsill? Or keep in their treasure box? Draw these things. Draw them to make them feel more real when you write about them. These items don't just accessorize a character, they have their own physicality. Drawing them helps you connect to these things in a tangible way. As you draw, try to have the item, or a close cousin to it, near at hand. Touch it as you draw. Make notes near the drawing about how it feels, the weight of it in your hand, its texture and use. For fiction writers, especially if you are writing in the realm of fantasy and your character's stuff doesn't exist in the known universe, you may have to make prototypes of the objects or work with similar things that exist.

Doodle Prompts
Character Accessories

These prompts are meant to help you get a feel for the things and places that touch your character(s). You may not end up filling your writing with descriptions of everything you draw, but drawing them can help you figure out what matters, in the sense that things are made of matter, they have weight. Drawing objects can get at the substance of them.

Make a list of the essential everyday items for a character. Draw these items.

What does your character carry around with them? Draw these items.

Where does your character sleep?
Draw the things nearby.

Where does your character go to think?
Draw the things nearby.

For a scene you're working on, look around
(in your mental image of it). List the things you see. Draw them.

2.3 | Drawing to Learn

When I was researching California's Owens Valley for my book, *A Land Between*, I found images of Mary Austin's sketches reprinted in Barney Nelson's afterword for Austin's novel *The Flock*. One drawing that stuck with me was of cayacs, leather pack bags used by shepherds over a hundred years ago. On her drawing of the cayacs she noted dimensions, drawing the bags on and off a wooden sawbuck saddle. The drawing showed not just the bags, but how they worked. While the images in her published books were done by professional illustrators, often using Austin's sketches for reference, the act of

drawing aided Austin in crafting her writing. Nelson remarked on how her drawings' "meticulous attention to detail gives Austin's work an unmistakable sense of verisimilitude."

Drawing what a character uses as they move through a story can help you, as it helped Austin, to understand the inner-workings of these things. Take for instance a belt. What if a character says a key bit of dialogue—*I love my best friend, my mom hates me, the earth is on fire*—but you miss it because while she said it she was also busy fumbling with a belt buckle, not fumbling intentionally as a literary device to prolong the moment, but because the writer who created this confused character has clearly never seen nor used a belt buckle.

One of the bits of storytelling advice I heard from a teacher (Amy Silverman) who was quoting her teacher, who very well could have heard it from another teacher, is "don't stick peas up your reader's nose." Since it was such a gift for me, in exchange I drew a cartoon of this literary axiom, as a panel in a page I made (for Amy and her co-teacher of Mothers Who Write, Deborah Sussman). I keep it pinned above my desk.

Don't stick peas up your reader's nose.

What does it mean? It's a caution not to include something unimportant to the story that the reader will ponder, mentally picking away at it in an effort to dislodge it from their mind, all the while missing whatever literary brilliance that came after the pea. A character's wonky use of objects, is a pea.

Shifting gears in a car your readers know is an automatic, is a pea. Eating a banana before peeling it, is a pea. Drawing what you're writing about can help you winnow out the peas in your writing before they lodge in your readers' nasal passages.

Doodle Prompts
Drawing to Learn

Drawing to Understand

Draw a common object to show how it is used. This may take a series of drawings.

Drawing the Familiar

Pick an object you use every day. Draw it from multiple angles. If it comes apart, draw the individual parts. Start with something small, a hair brush, favorite pen, a toothbrush, your keys. The focus is on discovery in the ordinary. I did this after drawing the 200 cartoons for *By the Forces of Gravity*. I had held a black Ticonderoga #2 pencil for hundreds of hours, but hadn't noticed there were two fonts used for the embossed letters until afterwards when I drew this pencil for my *Wordling* zine.

Do this for objects your characters use. Imagine them holding a pen or a toothbrush. Draw them using their stuff.

Drawing to Help a Project Along

Draw what you are writing about. For instance, if you're writing an essay about marsh grass, draw a diagram of the lifecycle of marsh grass. You might find an image online or in a sciency book. Redraw it, with the notes, in your sketchbook. Drawing it will burrow it deeper into your brain.

Go out to a marsh and draw a marsh grass leaf. While you're there, you can also write notes about the smell of the air, sounds you hear, thoughts that pop into your head.

2.4 | Drawing When Blocked

I've heard other writer's say, when they aren't writing, "I'm blocked," like they're trying to drive across town but can't navigate the traffic. As though there's a physical barrier between where they are and where they want to go. I haven't ever said this because it's not how I experience writing. I rarely know where I'm going, so I have no sense of being kept separate from my destination. The blessing of the literary rambler. However, for years I felt like I wasn't a real writer, just a person who wrote, and this feeling is for me the closest I've come to feeling blocked. I created a kindred traffic jam in my skull to make way for the parade of clowns yammering about my inadequacies. Step aside for the Grand Marshall of You Suck!

I don't have time for that nonsense anymore. I'm busy spreading doodle love.

Still, what is writer's block? And is it real?

In her article for *Penn State News*, "Probing Questions: Is Writer's Block Real?" Lisa Duchene quotes poet/essayist Julia Spicher Kasdorf, who answers: "It's as real as any kind of anxiety."

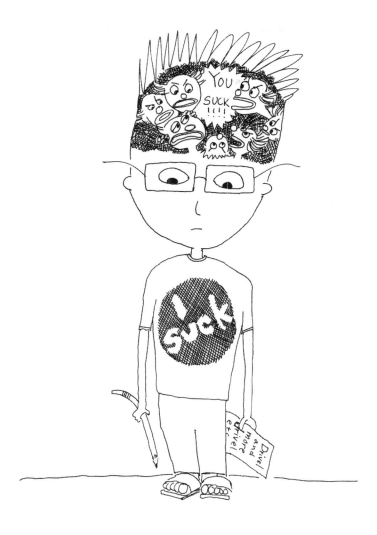

As a tree-lover, what excites me most in this article is the gift of Kasdorf's lovely perspective on writer's block: "Just because there aren't leaves on the trees doesn't mean the trees are dead or broken."

So take heart! You are not a broken writer, just a deciduous one, weathering the barren season to prepare you for the abundance when spring comes. And it always comes. At least until Earth's orbit slows and the planet collapses into the sun. Don't fret: Wikipedia says that won't happen for another 7.5 billion years.

Anne Lamott in *Bird by Bird* describes writer's block not as a block at all, more as a kind of emptiness and says that the challenge is to accept the empty hole so you can begin filling it up. She coaxes herself to begin filling in the hole by imagining she may die tomorrow: "Then I can decide to read Wallace Stevens for the rest of the morning or go to the beach or just really participate in ordinary life. Any of these will begin the

process of filling me back up with observations, flavors, ideas, visions, memories."

I like this. As a depressive sober alcoholic, imagining empty pits comes naturally for me. Being alive is about filling these pits up with what feeds the soul. The question is what to fill it with.

Yes, I am a broken record. How can I not be? Drawing is the CBD of a writer's life. Can't picture your character? Doodle her! Can't write a believable belt buckling? Doodle it! Can't write a danged thing? Just doodle! Anything. It really makes no difference what you draw. The important fact is that drawing is close to writing, but is not writing. It keeps you near what you love while you can't stand being intimate with your beloved. If you've drained all your words away, you can keep making marks on the page by drawing.

I keep two of Kafka's journal entries from 1912 near at hand. They remind me of what optimism looks like when you think you have none.

Even if you don't experience episodic depression or have a melancholic disposition like me and my dreary pal Kafka, you may find your writing flags from time to time. When this happens, when it feels like it'll be June 1 forever…draw. Just keep filling your journal with your angsty marks and, eventually, June 2 will come.

Doodle Prompt
Drawing When Blocked

Whenever you feel like your writing is blocked, draw. It really doesn't matter what you draw. Just doodle away. Be kind to yourself as you draw. Think about this doodling like raking the sand in a zen garden. You can make some cat paw squares and fill them with doodles. If a thought sneaks in, or a phrase comes to mind while you're doodling, just write it into the drawing. Let words come if they come. If no words come, keep doodling.

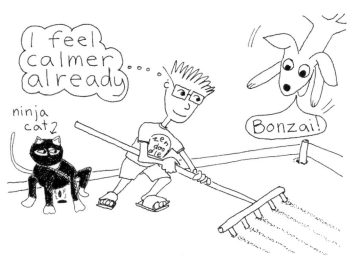

Try the prompt above in different places—sitting at your desk, in a park, at the beach, a library. Draw in the places where you often write. Or try places totally unlike these writing spots. Listen to different kinds of music. Try this prompt while unplugged. No phone ringer. No TV. No computer screen. Just you and the doodles. The idea is to give your mind a rest from fretting about not writing at the same time keeping you near to writing through drawing.

2.5 | Mental Maps

As a lover of wandering, I rarely do so without a map. Whether paper or digital, maps provide a long view of the landscape, giving me enough distance from my feet for patterns to emerge. Last time I was in Portland, Oregon, I planned a walk based on the tree canopies shown on Google Maps. The trees in real life were far more magnificent, their branches spanning the neighborhood streets, recalling my favorite hill to careen down on a bike as a kid in Berkeley, arms held high in the air, dappled light sparkling against my cheeks. Still, the constructed image on my phone screen helped me plan my way into this arboreal wonderland.

Despite my daily dependence on digital maps, I miss the days when drawing maps was a frequent necessity. Don't know how to get to Point Reyes? Let me draw you a map. I could then create a story on a scrap of paper of how to move from where we stood together to where you wanted to get to on your own. Isn't this what all stories are? Maps for another to use to plot out their own adventure.

Sure, after you've surveyed the land yourself and determined the best routes through. Writers are explorers in this regard, tromping about in the place between their minds and the world around them, charting a course for their readers. Even

if a writer has no sense yet of where they're headed, it helps to map out the lay of the land, what's known territory, what's still a mystery, to locate points of possible interest, and mark all potential danger zones.

At their roots, plots derive from the land. A plot is a "piece of ground." (*OED*) They have their own geography. Story plots are no different. You can map this. On paper.

Scientists believe human brains navigate thoughts and memories with maps. The hippocampus fabricates charts of our memories that guide us through our days, our relationships with other people, each step we take forward. It is the dwelling place of our genius loci, our spirit of place.

You can map this. On paper.

By extracting fine details, the kind seen only up close, these maps reveal patterns otherwise obscured by nearness.

{I dig how you break it down clear like Joyce in Finnegans Wake.}

Mental maps have a scale different from what gets marked in legends on geographical maps. When drawn, they often take the form of diagrams, abstractions from place, absent of rivers and mountains.

Familiar forms for cognitive maps, these charts of ideas, follow a pattern of nodes and paths, stuff I learned about when studying Kevin Lynch's theories of urban design in grad school at Cal. Cities, according to Lynch, can be reduced to places to linger in (nodes) and routes between these places (paths). In school, I contested this simplification of landscape, but it's my nature to question everything at first glance. Over the thirty years since I resisted my landscape architecture education, I've come to appreciate the utility of spare logic. If not for landscapes, at least for ideas.

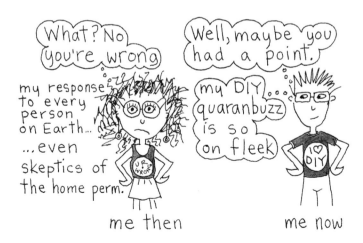

You can take any thought, whether it's a memory or hint of a story plot, and draw it out, using circles to contain the aspects of this thought (nodes) and lines to link aligned aspects (paths). You've no doubt created one of these cognitive maps. They are useful, if not a bit limited in their form. You could spice them up by coding the lines, using your personal linephabet, and rendering the nodes with your newfound grasp of light, shadow, and hierarchy. Compose the map to challenge the convention of placing the main body of the thought smack dab in the middle. What happens if you compose it slant? What alternative story structures does this suggest?

Another way to expand on the traditional Tinkertoy™ cognitive map is to imagine your idea as a landscape. Give your thoughts a geography. Make mental links into rivers with tributary streams that lead to an ocean. Draw mountains and villages. What kind of place would be a manifestation of your character's greatest fear? Look to Medieval maps for inspiration. They have a remarkable way of merging what is known with what is imagined.

Doodle Prompts
Mental Maps

Diagram relationships.

Start with a piece of writing for which you have a full draft.
You can use line and node graphics, spiced up with your own
visual vocabulary, to make this diagram. The lines represent
character connections, while the nodes indicate individual
characters. Play with line vocabulary, tone, and other drawing
techniques to indicate the nature of the characters and
their relationships.

You can do this same exercise to diagram scene locations,
significant moments in the story, the emotional tenor of the
story, your main character's state of mind.

Once you feel comfortable with making these mental maps,
you can repeat the prompt above for a story that has been
nagging you, but is not yet written.

Draw your main character as a landscape.

Imagine your character as a place. Is she an island? Is he a cave
in a dark forest? Do they appear to you as a vast field of corn?
Imaging walking through your character's mind as you would

a landscape. Is this place a city? A quiet garden? Outer space? Draw what you imagine. Label each element in the landscape that represents an aspect of your character.

Draw the story as a place.

Imagine your story—the arc of the narrative, the rhythm and beat of the chapters—as a landscape. Draw this place. Label the drawing elements as they relate to your story.

2.6 | Place Maps

When mapping out this book, I initially separated interior and exterior spaces. I reasoned that the outdoors would require location maps, while interiors could be drawn in plan like the kind an architect might make for a client. When I sat down to write the separate sections, I realized the flaw in my thinking. And not for the first time in my life, for this flaw is not actually a flaw, in the sense that it's a mistake (what Miles Davis said don't exist). More a character trait. I don't see hard lines between things. Maybe it's my training in math, all those times I was told that between two points lies a whole universe of more points. Or how in topology my body is homologous to a doughnut, meaning my guts are more outside me than my heart or brain. Or maybe it's the landscape lessons of ecology that have shown me the boundless nature of ecotones. Or the lifelong struggle with my own neurology that equipped my mind with few filters to divide me from the outside world, giving me pulsating impressions that I am at times connected to everything and at other moments without a self.

Based on these musings, I decided to collapse the outside mapping section with the interior planning one, addressing mapping regardless of the whole inside/outside conundrum.

In making maps, it helps to think about fractals. In 1985, my senior year of mathiness at Cal, I read about fractal geometry in *Scientific American*. Working from a formula in the article, my friend, who knew programming, wrote code for plotting out fractals known as *Mandelbrot Sets*, named for the guy who arrived at them first. Somewhere buried in my closet, I still have the pixelated inkjet prints of fractals that took all night to plot. Fractal geometry works on the iterative process of replication at varying scales. They mess with the sense of distance in a way similar to the seeming paradox of walking halfway to a wall does: how you can step halfway to the wall again and again forever and never get there.

Mapping has a fractal sense, regardless of what's being mapped. Patterns can appear similar as you zoom in and out, making a coastline resemble a piece of toast, the Mississippi delta mirror a neural dendrite. All very cool to think about. But what's revealed at any given level of scale is what matters in story building.

The scale you need to map depends on the story.

In choosing what to map, a good place to begin is with the main character. Draw maps of the places they inhabit. Start big and zoom in, making a new map every time you zoom to an important scale. Some scales to consider: galaxy, solar system, planet, continent, region, town/city, neighborhood, home, room, bed. There may be patterns common to all your maps and these might be the rug that ties your story together. At the same time, each scale reveals aspects of the story that are unique to the scale. Some truths about a person can only be revealed at the scale of their bedroom.

Kafka's *Blue Octavo Notebooks* begins with this sentence: "Everyone carries a room about inside him." In his writing, Kafka's rooms feel like a kind of Tardis, containing a larger universe than its space feels fit to hold. This is what I love about his stories, all his words, and the tentative doodles he made in his diaries. His rooms are confined and immense simultaneously and to excruciating degrees. One of his most referenced quotes, sometimes presented as a poem called "Learn to be Quiet", reveals the accordion nature of a room:

"You do not need to leave your room. Remain sitting at your table and listen. Do not even listen, simply wait, be quiet, still and solitary. The world will freely offer itself to you to be unmasked, it has no choice, it will roll in ecstasy at your feet."

Room began as a word for space and expansiveness. When mapping a room, keep this etymology in mind. The act of drawing a seemingly contained space like a bedroom or a shed can conjure images, ideas, any number of thoughts to feed a story. Make notes as you draw.

Rooms exist in the outdoors, with sky and tree canopy as ceilings. Human history abounds with outdoor places used as kitchens, dance halls, temples. For 330 years, the Law Rock in

Iceland transformed a rift valley into a courtroom. You can draw the outdoor rooms that contain the life of your characters.

Unlike room maps, location maps are relational. They situate one place (A) in relation to another (B), and so on through the alphabet. They can indicate the route between places. A map's scale depends on how far it is from A to B. Distance, of course, becomes fractalish, especially as it gets compressed by the mode of travel. Geography, which literally means *earth writing*, is one of the human concepts that has been declared dead of late. Place, cynics claim, has no meaning anymore, because space is compressed by digital technology. I thought this was a 21st-century post-analog firestorm on geography, another thing to pin on millennials, but it turns out the husband/wife futurists Alvin and Heidi Toffler declared geography dead in 1970, with their book *Future Shock*. So, less a millennial bonfire, more an old school smolder.

Either way, I still believe in place, maps and all.

Doodle Prompts
Place Maps

Scene Sketches

Draw or map a scene in your story. If you make a map, you can draw in the movements of your characters. This is super helpful for navigating a character across a room or through a park.

Draw the floorplans for the places where your main characters live. For every room, mark the doors and windows, place the big furniture. You can use words to note important features of the room. Draw the overall layout of the interior. Kitchen, bathroom, hallway. If there are multiple floors, draw each one separately. Note the location of the stairs. You don't have to draw these plans to scale, though try to keep to proportions that seem right.

Draw elevations for significant rooms. This is just like a floorplan but for a wall. If the wall has windows, draw the view to the outside through these windows.

Location Maps

Draw a map that includes all the locations in a work in progress. Don't worry about drawing to scale. Focus on the connections between places where the story unfolds. Include, as drawings or with notes, features important to the story. Depending on the story, you may need to draw more than one location map, zooming in on an area where a lot of scenes occur.

2.7 | Visual Shorthand

Everything has structure. In building a story, poem, essay, novel, or memoir, this structure holds the writing together. Three ways to recognize structure quickly is by drawing thumbnails, storyboards, and diagrams.

Visual thumbnails are small drawings. They are intentionally small to keep you from toiling away at them for too long, stuffing them with details. They follow the same logic that says if you don't want to eat a lot, use a small plate. What ends up in a thumbnail is the indispensable stuff, what you won't want to edit out during revisions. Quick to do, thumbnails are handy for sketching out the storyline, narrative structure or character development. Thumbnail sketches are great for organizing scenes. While they're named after a thumbnail, they range in size, usually not exceeding the dimensions of an averaged-sized index card. You can even draw them on actual index cards, so you can shuffle them around on a table or on the floor. As with all the drawings done by writers, words belong in them. You can think of thumbnails as comics panels and use dialogue. Or consider them like photographs and write captions to remind you of what scene they represent.

A storyboard is the thumbnail's cool friend, the one who has an entourage of Hollywood pals. Essential in the film and animation industry, storyboards are like a quick run-through in stills made before the cameras roll. Hayao Miyazaki's storyboards have beautiful pencil and watercolor drawings paired with notes, five drawings to a page, each in a rectangle in landscape format. For hundreds and hundreds of pages. They are stand-alone amazing, so his film storyboards are published as books. Other storyboards map out important points of view and action and have no notes beyond simple directional information—*drop anvil on Wile E. Coyote. Meep, meep.*

Diagrams of writing follow a thread through the work to expose the movement or pattern it makes. This can be done at any stage of the writing, though it's particularly useful in revision (or in studying another author's published work).

p.1 Call me Ishmael...

lots of time spent at the Spouter Inn.

p.137 finally Off to sea! At last the anchor was up, the sails were set, and off we glided...

p.169-182 Dash off a brief treatise on cetology... then carry on with the hunt.

p625 There she blows! A hump like a snow-hill! It is

MobyDick!

New book idea, 1841 Nina Melville

They often look like quilting patterns, which makes sense, since both work to bind fragments together. At the opening panel of NonfictioNow 2018, I scribbled the drawings projected on the screen while the speakers read and talked: diagrams of Virginia Woolf's *To the Lighthouse*, John McPhee's 1973 *New Yorker* piece, "Travels in Georgia," and another title I didn't catch. In addition, each panelist who read from their own work showed what they called their "version of Freitag's Pyramid." All were fascinating spare portraits. "Part of the beauty of them," the moderator, essayist Sarah Viren, said, "is that the self is fragmented." She was speaking about essay collections, but it applied as well to these diagrammatic drawings.

The most exciting writing right now is hybrid form, work that rejects the grand narrative as the sole model for storytelling. If a story follows the traditional narrative arc of Freitag's pyramid, there's hardly a need to draw it. Experimental hybrid form has more complexity and the patterns can become muddled without a visual shorthand to bring to light the underlying structure.

Author's diagrams, redrawn in my note book

Venita Blackburn

Angela Morales

The reader's Path

Chen Chen

Elissa Washuta

dark mystery

hot core of truth

NFN 2018

These diagrams can follow a character's emotional movement through the work. Or the use of a repeated image. Or the density of the storyline. Or a relationship between characters. One story can have multiple diagrams, like a music score when multiple instruments come into play. They can be fully abstract or a hybrid kind of map.

Doodle Prompts
Visual Shorthand

What you need:

- A work-in-progress
- Index cards

Thumbnails

Take a work in progress, something not too long. If your WIP is lengthy, do this prompt for a chapter. Make a list of the main moments; these can be scenes or kernels of an idea, whatever you feel is moving the piece forward. On index cards, draw what you listed, one item per card. Lay these cards out on a flat surface. Move them around. See if there might be another way to organize these moments. Look for repeated images. Decide if you want the repetition.

Storyboarding

For this prompt, you will pick a scene you have already written and develop a storyboard for it. Usually a storyboard comes before the drafting of a scene, but to get the feel for storyboarding, start with a scene or story you've already

written. In the boxes, draw the action. Next to each box, write notes, bits of dialogue, names of characters engaged in the action. Voila! You have a storyboard!

You can also use the thumbnail index cards you just made, if you want. Tape them to pieces of paper in the order you settled on and write notes next to them, bits of dialogue, names of characters engaged in the action.

Diagramming

Using a work in progress for which you have a complete draft, make a list of features, actions, scenes, colors, chapters, any structure-related aspects of the writing. Draw a diagram of how one of these listed features works in the manuscript. You can repeat this exercise for any and all the listed items. The intent is to give you a clearer picture of the manuscript structure and to identify what needs shoring up or reorganizing.

Fret not, friend
Thou maketh
a most
awesome
Assidacat.*

*Little Known Medieval Fact:
 The Assida, or Ostrich, lays its egg
 in sand when the Pleiades are in view.

Hybrid Form

Creating finished hybrid work
with words and drawings.

3 | Hybrid Form

It may happen that you get so excited about mingling your drawings and writing that you have an urge to create hybrid work, not solely as process drawings, but as a new kind of storytelling or lyric art made of words and drawings. Excellent! Hybrid form is experiencing a beautiful bloom right now, not just as a mingling of poetry and prose or other textual cross-breeding, but also in inviting images onto the page. I differentiate illustrations from visual hybrid form by the degree to which the drawings carry the story. To *illustrate* is to shed light on a thing. Drawings in hybrid form are part of the thing itself, not light cast on it to make it more visible. However, I'm not the gatekeeper of hybridity, so draw and write to your heart's delight and call the union you create whatever feels right!

The body of published work in hybrid form is a vast ocean with plenty of room for you. Come join the company of hybridists whose creations in words and drawings have enriched the world for centuries. To see what humans have been doing with words and drawings, pour over Medieval manuscripts, whose margins are filled with flourishes, doodles, miniature painting, and amazing cartoons called drolleries. While you may not have access to an actual ancient book, you can find scanned pages on many library and museum websites. Seek out the work of William Blake, Djuna Barnes, Stevie Smith,

Bianca Stone, and Ariel Gore, established writers who have published in visual hybrid form. Find comics artists whose work sets your heart on fire. I can't list all my heart-burning favorites, but here's a few whose work I have deep love for: Emil Ferris, Julia Wertz, Liana Finck, Art Spiegelman, Tom Hart, Alison Bechtel, and Lynda Barry.

Words began as pictures. Over thousands of years, some cultures began to separate the two forms of mark-making, and to think of them as distinct from one another. Words and drawings belong together. Maybe it's the visual nature of social media or publishers' efforts to keep print media alive, but every day I find more and more work that mingles words with drawings. And still more that merge other visual imagery with writing, such as the photographic collage in Claudia Rankine's book, *Citizen*.

Nature abounds with hybrid inspiration.

Fun fact: An *ecotone*, where two ecosystems intertwine, is an environment rich with new life and diversity. Ecotones are nature's nurseries, where novel life emerges.

Hybridity is the ecotone of language. Hybrid-form work offers many options for writers—from prose poetry to comics poetry, graphic memoir to speculative memoir, and beyond.

For a long time hybridity, what the *OED* defines as the "offspring of a tame sow and wild boar," was stigmatized. When I was in poetry school, I was admonished for putting

a tiny picture of a castle keep on the page with one of my poems. A castle keep is a fortified area where royalty retreats with what they hold dear, what they hope to *keep*, so the objections—the poem should stand alone, the drawing is a crutch—felt ironic, like this tiny picture threatened the purity of the written word. The human mind has an obsession with dichotomies and judgment. Put two things together and a human will see one as better than the other. Unless this human, as Lynda Barry often points out, is a four-year-old. Judgment is a learned distinction and it can be unlearned.

I hope this book has given you the tools and enthusiasm you need to take on your own brain's urge to separate words from drawings. If you want to make hybrid work, make hybrid work! If your brain tries to tell you this is wrong or you aren't good enough to even try, say "thanks for your input, but NO, I want

to do this cool stuff right now." If your brain persists, play it a distracting song. When I'm drawing or writing and my brain starts to cast doubt on what I'm creating, I take deep breaths, yoga breaths I learned in the late 1960s from my hippie dad, who spent a lot of time meditating and doing headstands. If your judgy brain still won't let up, contain it to a single piece of paper or to the margins of your pages where it can pour out its snarky shade. Turn your fears into a cartoon character. Give it a silly hat. It's very difficult to take seriously the scorn of anyone in a silly hat. Try to persist. Judgy-brain gets bored easily and will wander off to needle you about something else.

To give you a sense of how to mingle words and drawings, here's a revised extract from my craft article, "Picturing Hybrid Form," published in *Brevity*:

> Visual hybrid-form work can be categorized structurally, with a focus on word/picture relationships.
>
> The categories include:
>
> **Juxtaposed:** This is how I constructed *By the Forces of Gravity*. Narrative free verse is paired with cartoons, illustrations, or comics to give the words and pictures room to breathe, so readers can decide what to give their attention to. By maintaining distance, the words and pictures say the same thing, for emphasis, or they say different things, to provide perspective. The following poem/cartoon from *By the Forces of Gravity* speaks to my feelings of smallness and ill-preparedness:

45

I'm still not sure how this happened
But I got into Maybeck High School

They don't seem to care about the math test
Or transcripts

It also turns out there are scholarships
For broke kids at this school

They're letting me go
And all my dad has to pay for is books

Luckily school starts with a camping trip

I know how to camp
So at least I'll have the first week covered

But I don't know anything
About going to high school

I'm freaking out a little

Actually
I'm freaking out a lot

August 1975

Dear Becky,
We are pleased to offer you admission to Maybeck High School... blah blah blah...words that freak m...

Fun flashback! Now back to the hybrid-form categories.

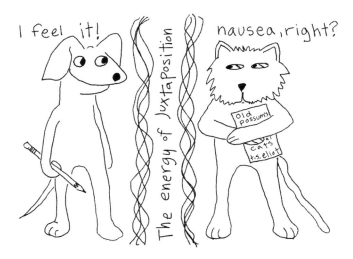

It's like two people standing side-by-side, each one a distinct person, but creating resonance by their closeness.

Braided: Like the text-only braided essay, except in this case one or more of the threads is visual.

Integrated: Options abound! Comics art integrates words and pictures. Comics poetry mingles words and pictures as well, but is often less narrative, like lyric essays. Illuminated manuscripts turn words into elaborate images. Hermit crab essays that appropriate an image could be fun to try, though it kind of Klein-Bottles my head thinking about what this might look like. I tend to fill space in drawings with words. This is another form of integration.

The balance between words and pictures influences the reader's experience, another reason I decided to use juxtaposition in my memoir. I wanted readers comfortable with words to feel as welcome to the pages as consumers of cartoons. I considered creating a more traditional graphic novel form, but those take tons of planning and I'm not a planner, but also word lovers might not pick up the book and the voice in the poems would have been lost among the drawings.

Well, there you have it! Apply your newfound doodling voice to creating hybrid form. Fret not about the naysayers, shade-casters, and gatekeepers. They are made of mist. You have a visual voice. Go forth and sing!

Happy hybriding!

Tail End

4.0 Introduction

4.1 Resources and Inspiration

4.2 Extra Credit Prompts

4.0 | Introduction

Staying in the doodleverse.

In a Medieval Bestiary, while discussing flying fish,
the scribe wrote this mind-blowing aphorism for life:

> "You do not get anywhere by starting.
> You get there by pressing on."

Yes! This is my charge to you, gentle doodlers. Press on!

As a compulsive explorer of new territory, it's taken me
decades to come around to embracing perseverance, to not
giving up after barely getting going. My physical fitness history
(easily accessed among the dust in my closet) is testament to
my struggle with pressing on. (BTW, anybody need a kettle
ball?) However, every day that I nibble at my writing/drawing
projects teaches me the value of stick-to-it-ness.

Every book on earth began with one mark on the page. It's all
very Lao Tzu. And true.

This book has been about getting started, but the real journey
is before you now.

4.1 | Resources and Inspiration

In this last section are references and ideas for keeping at drawing. Like anything that involves the body, neglect breeds neglect. You don't have to draw every day. You don't have to draw at the same time every day. You just need to remain open to the possibility of drawing. You do this by drawing, of course, but you also do this by looking at other peoples' drawings, by believing that images are more than pretty pictures to adorn the written word, by becoming a life-long student of the line and light.

Tools

If you want to explore fountain pens, I recommend you check out **The Goulet Pen Company** (www.gouletpens.com). It has a great website, full of videos and info on pens and ink. It's your open door into fountain pen nerd heaven. I relax watching Brian and Rachel Goulet talk about drip and smear tests.

For pencils galore, check out **C.W. Enterprise** in New York (and online at cwpencils.com).

And for more pencil love, watch shop owner **Caroline Weaver's TED Talk**, "Why the pencil is perfect." It's a delight. (Search for it at ted.com.)

Print Books

When I die, I'm going to haunt all the musty indie used books stores of the world. So, just like IRL, only I'll get to stay past closing. Since I began putting this book together, I've been browsing the shelves of these palaces of print, looking for drawing books. I also have been filling my shelves with them at home for years. Here are a few from the awesome artists, cartoonists and writers who contributed their wisdom throughout my life and to this little book. Some are easy to find while others may require multiple hauntings of used book stores. Horrors!

Books that have instruction, exercises, or general wisdom about drawing:

Lynda Barry
- *Syllabus*
- *What It Is*
- *Making Cartoons*

Arthur Wesley Dow
- *Composition: Understanding Line, Notan and Color* (first printing in 1920 by Doubleday, but still available through Dover, a 2007 reprint)

Alois Fabry
- *Sketching is Fun with Pencil and Pen* (1958, The Studio Publishing)
- *Sketching Basics* (Mud Puddle, 2006) Note: this is a reprint of the 1958 *Sketching is Fun* Book with only the pencil sections.
- *Water-Color Painting is Fun* (1960, Avenel Press)

Jack Hamm

- *Cartooning the Head & Figure* (I always have this book near at hand. It's full of helpful reference drawings, though it was published in 1967 and reflects the time's limited view of humanity as straight and white.)

Tom Hart

- *The Sequential Artists Workshop Guide to Creating Professional Comic Strips*
- *The Art of Graphic Memoir: Tell Your Story, Change Your Life*

Virginia Hein

- *5-Minute Sketching: Landscapes*

Scott McCloud

- *Making Comics*

Mary Philadelphia Merrifield

- *Light and Shade: A Classic Approach to Three-Dimensional Drawing* (first printing in 1908, Dover Edition 2005)

Jennifer Orkin

- *100 Days of Drawing*
- *The Sketchbook Idea Generator*

William Powell

- *Perspective*

Joseph Slusky & Chip Sullivan

- *Impulse to Draw*

Chip Sullivan
- *Drawing the Landscape*
- *Cartooning the Landscape*

What follows is just a tiny taste of the vast expanse that is the ever-growing universe of drawing and language:

Alison Bechdel
- *Fun Home*

Eleanor Davis
- *Why Art?*
- *The Hard Tomorrow*

Emil Ferris
- *My Favorite Things Is Monsters*

Liana Finck
- *Passing for Human*

Ebony Flowers
- *Hot Comb*

Ariel Gore
- Her books mostly use words, but she draws awesome feminist aphorisms and makes coloring books: *Advise for Hybrid Beings* and *Fascism Fatigue*

Misha Maynerick
- *This Phenomenal Life*

Hayeo Miyazaki
- *Spirited Away Storyboards Book*

Lauren Redniss
- *Radioactive*

Nick Sousanis
- *Unflattening*

Jen Wang
- *Koko Be Good*

Julia Wertz
- *Museum of Mistakes*
- *Tenements, Towers & Trash*

The Internets

There are more wonders to explore through the miracle of cyberspace. To keep me connected to the big giant doodleverse, I follow people who draw on Instagram. Here are a few to get you started:

@virginiahein
@peterdraws
@augustwren
@ohn_mar_win
@scottlava
@thesketchbookproject

@thenearsightedmonkey
@kaalogii_kisses
@shachidreams
@landisblair
@lizatlarge
@rfishewan (me!)

The Internets and Instagrammers evolve, of course. To keep up with newly discovered resources and inspiration about drawing and the writing life, visit the doodling section of my website: www.rebeccafishewan.com.

There you can also see more of my work (and color!), as well as sign up for notifications about new articles, blog posts about doodling, and other news from the doodleverse.

I'll leave you with these final thoughts from the Slusky/Sullivan book, *Impulse to Draw*:

> "To Draw is to take a poetic leap.
> The leap connects us to the world,
> The leap is the translation."

Leap on!

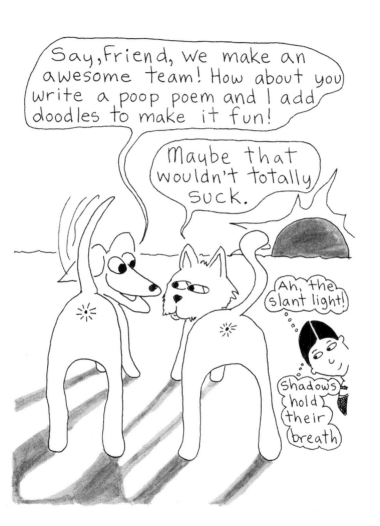

4.2 | Extra Credit Prompts

The end of a book feels like a springboard to the next adventure. These prompts are offered with this in mind.

Let's bring color to this leaping off party!

But first, a question: What is color?

Light waves come in different lengths; long ones look red and the shortest waves that humans can see appear violet. Light from the sun contains all the colors of the rainbow and appears white until the light gets bent (by rain drops in the sky, for instance) and individual colors appear like magic (as a rainbow!). Recall on page 38 when I explained that the eye doesn't see an object, but instead sees the light bounced off the object? As it turns out, objects can absorb light waves and what they don't absorb bounces off them and into your eye. So, if you look at a Granny Smith apple it looks green because the apple absorbed all the other colors and left only green to reflect off its surface and gleam into your eye.

Fun Fact: The outer layer of polar bear fur is so good at bouncing light, it reflects all the visible wave-lengths, which is why the bears appear white.

Another Fun Fact: Light waves move through water differently depending on their length. Short violet and blue waves can wiggle deeper into the ocean than long red waves, which is why everything looks bluish when you go SCUBA diving. Until you shine a full spectrum light on a rock and it explodes with color! Which begs the question: Why are creatures who live on deep-water rocks so colorful, if their color can't be seen? Which begs an answer: When submarine rock-dwellers evolved their colors, they didn't care a whit about human beings and their eyeballs.

So, color. Let's play with it.

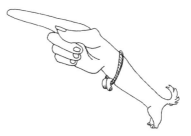

Doodle Prompt
Extra Credit: Coloring It Up

Add color to what you already can do in black and white.
Do any of the prompts in this book using:

- Crayons
- Colored pencils
- Watercolors

You can stipple in pink, scribble in blue, make a mental map using all the colors of the rainbow. Play with color and see how it alters what you draw.

Doodle Prompt
Extra Credit: Find Your Color Palette

On a blank piece of paper (can be in your sketchbook), make a bunch of kitty paw squares. Fill each one with a single color. Next to each color, note how this color makes you feel. You can do this prompt while thinking about a particular emotion, like anger. Fill a page with angry color squares. Do the same with joy or sorrow.

These color palettes can find their way into your writing to support the mood your words are creating. Over time, this exercise will reveal to you a color palette that suits you, much like your linephabet.

Doodle Prompt
Extra Credit: Doodle During Zoom (or other online) Meetings

As I mentioned in the tools section (1.1), I use waterproof ink and watercolor paints. Since the COVID-19 pandemic started, I discovered that I can paintdoodle during Zoom meetings. It helps me listen and makes my notes way more interesting.

Prepare space on your desk that will be off-camera during the meeting. Have your sketchbook and whatever drawing tools you want to explore. It's good to stay muted for this, especially if a heap of crayons that you keep rummaging through is involved.

Listen to whatever is being discussed while you draw/paint. I like to stay with abstract shapes—spirals, circles, squares, and loopy lines are my faves—so I don't get too distracted from whatever other people are saying about whatever is on the agenda. Sometimes these abstract doodles become a duck and I just let the duck happen, but I start the doodle without a plan other than to keep myself attentive in the meeting. The duck is just a happy little accident, as Bob Ross called magical things that happen while painting.

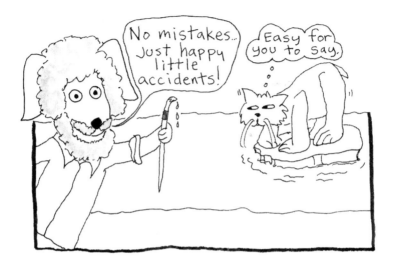

But wait! This is so rude! How dare anyone not just stare into the camera like a postage-stamp-sized portrait painting?!

Well, science supports the act of doodling in meetings.

Very important truth: Studies show people who doodle are more attentive (one scientist found that doodlers retained 29% more rando information than non-doodlers).

Why? Doodling wakes up your brain. Sunni Brown, a renowned doodle consultant, expounds on all the benefits of doodling in meetings and other places you may struggle with waning attention, in her book, *The Doodle Revolution*.

The awesome thing about Zoom (and there isn't a ton of Zoom awesomeness) is that you can bring way more doodle gear to meetings. I'll concede that bringing my watercolor kit to an in-person meeting would be a distraction, but not so on Zoom.

If you want to try doodling with watercolors and waterproof ink, you can cover your note paper with a wash of color, let it dry, perhaps while you're talking, then you can draw and write notes over the lovely wash of color. You might like to use a slightly thick paper so your notes don't wrinkle too much.

I look forward to the day when people can sit together in a room again, breathing one another's air without fear of dying, but I'll miss my Zoom doodle sessions (aka faculty meetings). It's like the olden days when people talked on landlines, tethered in-place with a cord, and resorted to doodling to keep their focus during long conversations. While we wait for the day when breathing together is safe, we can bring full color doodling to the gloom of Zoom.

Color on!

ACKNOWLEDGEMENTS

So many people have been instrumental in nurturing my drawing/
writing life, encouraging the merging of ways to make marks on a
page. Some draw, some write, some do both, but without all their
influence, I wouldn't have been able to create this book. Many of
them I met as teachers, as friends and family, and so many more
I grew to love from hours spent in wonder as I poured over the
pages of their books, their canvases in museums, gazed at their
animated cartoons, comic books, graphic novels or drawings
posted on IG. Their words/drawings set my soul ablaze. Special
thanks to Franz Kafka, Lynda Barry, Emily Dickinson, Julia Wertz,
Chip Sullivan, Maurice Sendak, Ariel Gore, Joe Slusky, Alyssa Graybeal,
Sue Matthews, William Blake, Scott McCloud, Chelsey Clammer,
Nick Sousanis, Maggie Nelson, Art Spiegelman, Herman Melville,
Andrea Gibson, Alois Fabry, Georgia O'Keeffe, Luna, Ali Liebegott,
Emil Ferris, Wayward Writers, Liana Finck, Farel Dalrymple,
Bri Noonan, Una, Liz Prince, Kate Beaton, Joy Young, Jesse Duquette,
Judy Grahan, Jack Hamm, Eavan Boland, Amy Silverman, Anne Carson,
Gabriel Garcia Marquez, Charissa Lucille, Frida Kahlo, Eleanor Davis,
Willa Cather, Medieval manuscript illustrators, Jorge Luis Borges,
Bianca Stone, Kathleen Aldrich Tanaka, Sappho, Tom Hart, Maya Angelou,
Alison Bechdel, Adrienne Rich, Marcel Proust, Dr. Seuss, Norman Dubie,
Tommi Parrish, Beckian Fritz Goldberg, Tyler Cohen, Jeannine Savard,
Deborah Hilary Sussman, Djuna Barnes, Stevie Smith, Claudia Rankine,
Bob Ross, my students, my cohorts in school when I was learning to
write and draw, Maud Reinertsen, Naomi Kimbell, HippoCampers,
Dave Kinstle, Amber McCrary, Virginia Hein, Sari Philipps, Maria Mahar,
Thom Strich, Uncle Ernie Nordli, Grandmother Stephanie Barrett,
Great Grandmother Isabel Morton Fish...and so many more! Thank you
for helping me find my way on the page. Drawing and writing is a
joyful rich part of my life because of you.

Thanks to DIY MFA and *Brevity* for giving me the space online to write/draw about drawing and hybrid form. Thanks to Sarah Viren, Venita Blackburn, Angela Morales, Chen Chen, and Elissa Washuta for sharing your awesome literary diagrams at NonfictioNow 2018.

Thank you, readers. I thought of you while I put this book together to keep the act of drawing as a possibility in your heart, to help you make it a reality in your writing life. You helped me make a funnier, kinder book.

Immense gratitude to these wonderful authors for their lovely blurbs: Vanessa Berry, Laraine Herring, Elizabeth Kadetsky, and Randon Billings Noble. Reading your blurbs makes me so happy! Reading your books fills me with awe.

For the wonderful book design, thank you so much, Lindsay Enochs! I love the care you took to make the words and cartoons fit together on these small pages. You helped make the book so cute and approachable.

For carrying the spirit of this book from its first spark of an idea, over a delicious breakfast in Lancaster after HippoCamp 2018, to the release of it fully-formed as this tiny delight of a book, Donna Talarico-Beerman, a million billion thanks! You are amazing! I'm so glad you've found a quiet place to chill in your very busy life. Just a thought...how about doodling in the camper? No pressure.

Thanks to my dad, Peter Fish, for being a constant fan. I've learned so much from you about perseverance. I may never match you in miles logged, but it's your chuckle I hear when I draw a James Joyce reference into a cartoon. Thanks for laughing.

Thanks to my Arizona family for helping me find the space to write and draw, especially my kids, Isabel and Keegan, my husband, Joe, I love you all so much.

And thanks, Odin and Bigfoot, for being the prime inspiration for puppy and cat in this book. You guys are ridiculous and wonderful.

ABOUT THE AUTHOR

Poet/cartoonist Rebecca Fish Ewan's passion is mingling text with visual art, primarily in ink and watercolor, to tell stories of place and memory.

Author photo by Charissa Lucille

Her hybrid-form work has appeared in *After the Art*, *Brevity*, *Crab Fat*, *Survivor Zine*, *Hip Mama*, *Mutha*, *TNB*, *Punctuate*, and *Under the Gum Tree*. Her illustrations and essay, "The Deepest Place on Earth," were published in the Literary Kitchen anthology, *Places Like Home*.

She is the author of *A Land Between*, *By the Forces of Gravity: A Memoir*, the chapbook *Water Marks*, and her newest book, *Doodling for Writers*. Rebecca has an MFA in creative writing from Arizona State University, where she has been a landscape design professor for 25+ years.

She grew up in Berkeley, California, and lives with her family in Arizona.

ALSO FROM BOOKS BY HIPPOCAMPUS

Selected Memories: Five Years of Hippocampus Magazine

By the Forces of Gravity: A Memoir by Rebecca Fish Ewan

Dig: A Personal Prehistoric Journey by Sam Chiarelli

The Way Things Were anthology series:
Air
Dine
*Ink**
*Main**
(*forthcoming in 2021)

Available at **books.hippocampusmagazine.com**
and wherever you buy books.